A DESIGN MANUAL

Second Edition

A DESIGN MANUAL

Second Edition

SHIRL BRAINARD

Artist/Educator

Prentice Hall, Upper Saddle River, New Jersey 07458

Library of Congress Cataloging-in-Publication Data

Brainard, Shirl.
 A design manual / Shirl Brainard. — 2nd ed.
 p. cm.
 Includes bibliographical references and index.
 ISBN 0-13-759234-5 (alk. paper)
 1. Design. I. Title.
NK1510.B773 1997
745.4—dc21 97-37837
 CIP

Editor-in-Chief: *Charlyce Jones Owen*
Acquisition Editor: *Bud Therien*
Assistant Editor: *Marion Gottlieb*
Editorial Assistant: *Gianna Caradonna*
Production Liaison: *Fran Russello*
Project Manager: *Publisher's Studio*
Prepress and Manufacturing Buyer: *Bob Anderson*
Cover Design: *Pat Woscyzk*
Interior Design: *Publisher's Studio*
Electronic Art Creation: *Publisher's Studio*
Copyeditor: *Kathy Glidden*
Marketing Manager: *Sheryl Adams*

This book was set in 11/14 Stone Serif by Stratford Publishing Services, Inc.
and was printed and bound by Hamilton Printing Company.
The cover was printed by Lehigh Printing Company.

Printed in the United States of America

10 9 8 7 6 5 4 3

ISBN 0-13-759234-5

Prentice-Hall International (UK) Limited, *London*
Prentice-Hall of Australia Pty. Limited, *Sydney*
Prentice-Hall Canada Inc., *Toronto*
Prentice-Hall Hispanoamericana, S.A., *Mexico*
Prentice-Hall of India Private Limited, *New Delhi*
Prentice-Hall of Japan, Inc., *Tokyo*
Pearson Education Asia Pte. Ltd., *Singapore*
Editora Prentice-Hall do Brasil, Ltda., *Rio de Janeiro*

This book is dedicated to Esty,
who's always there . . .
and to my grandchildren, whom I
love dearly!

Contents

Part **3** PRINCIPLES OF DESIGN

Part 4 APPLICATION OF PRINCIPLES OF DESIGN AND MORE

Preface

George Moore said, "Art must be parochial in the beginning to become cosmopolitan in the end." I would like to update this quote with a paraphrase, "(Design) must be limited in the beginning to become knowledgeable and sophisticated in the end." This is the context of my goal: to present very basic material and concepts that can be readily grasped and understood in order to meet today's students' needs.

The general profile of the two-year college student is unique. Most are trying to define, as well as live in, their newfound world of academia. Many have not had the educational/cultural background of the traditional university student. Some are trying to master the English language. Another is the older student who has lived one life and is now tackling another for self-fulfillment. Still others may be single parents taking a new direction while still working forty hours a week.

It appears that much of our visual literacy today is based on magazine advertising or TV. I have, therefore, deliberately used commonplace, easily recognized illustrative material and have arbitrarily offered information in a conversational, direct tone . . . hopefully humorous at times.

At the end of each chapter there are ideas for discussion, a key-word, and a review, as well as a few project ideas. This gives the teacher a chance to share not only my material, but to expand or further develop an idea based on the individual class.

This is not a book about specific tools or media. It is not restricted to one design area. Rather, it is a "bare bones" look at the essence of good design; a book to make us think and explore ways of approaching our work in our chosen design field.

Our role as teachers/artists/designers, I believe, is to act as mentors: to guide, to encourage, and praise the growth of the student's interest and intellect, and not be alarmed by a lack of sophistication. We can best do this by remembering that we did not always know what we know now! Be enthusiastic, productive, knowledgeable, and sharing—and have a passion for what you do!

Our role as students (and artists are *always* students!) is to open our minds to all of the information offered to us, and then be selective

about what is best for our particular needs. But, again, have passion for your work!

In the words of Voltaire: "The passions are the winds that fill the sails of the vessel! . . . they sink it at times; but without them it would be impossible to make way."

Acknowledgments

This book is based on my teaching experience in a community college art program, as well as my own experience as an artist. However, all of this could not have been accomplished without the help and support of family and friends. A big thank you goes to my astute 91-year-old mother who was my "number-one editor"; my artist friends Bob Fleck, Donna Garin, and Janet Means, who read and critiqued the original first edition and gave me ideas for revision; as well as those "anonymous" reviewers who gave suggestions.

Fellow artists are represented in many of the illustrations. Thanks go to them for their generosity, interest, and helpfulness.

Thanks, also, for the cooperation of the museums and galleries who shared reproductive material and information, and to companies and associations who also provided visual material and helped me track down other photographers, designers, and artists.

And of course a big thank you to the publisher's staff; assistant editor, Marion Gottlieb; production staff at Publisher's Studio and cover designer, Pat Wosczyk. Thank you to the publisher! Thank you . . . everybody!

Part

1

INTRODUCTION TO DESIGN

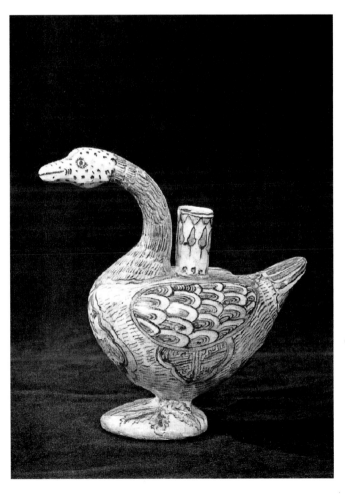

Chapter

1

What Design Is

What is Design Supposed to Mean?
All Designs Have Them?
Theory

What is Design Supposed to Mean?

A *design* is a creative endeavor to solve a problem. A design is the end result—what you have when the problem is solved. It *is* the solution. *Composition* is the *way* the components, parts, or elements are used or arranged to reach the solution. A design *has* composition.

Design is all around us. We often say that something is well designed, especially if it *functions* well. We understand and are aware of new designs in cars, clothing, and home furnishings, but look around you. The parts that make up these common designs are in nearly everything we know, whether designed by man or nature. These parts or components we call *elements:*—LINE—SHAPE—TEXTURE—VALUE—COLOR——in a SPACE.

The *way* these parts are used to compose the design are called *principles*. These principles are: SPACE DIVISION—BALANCE—UNITY—and EMPHASIS. We have to remember as we start this exploration about design that we are not talking about what "art" is. We are speaking about design. Many forms become art because of their design. An example of this is a refrigerator—a refrigerator is a design, but is not considered art.

All Designs Have Them?

Think about the elements: SPACE, SHAPE, LINE, TEXTURE, VALUE, COLOR.

Do buildings have them?

Does a tree have them?

Does a painting have them?

Did your dinner last night have them?

ALL DESIGNS HAVE THEM.

It is easy to agree as we look at different things that, yes, all designs have these parts or elements.

But WHO said that these particular things are the basic parts of design? The credit for analyzing various forms and structuring our basis for design theory goes to the Bauhaus. This was a school started in Dessau, Germany in 1919 by Walter Gropius, an architect. He brought together a group of artisans with various training to lay the

1–1
The logo of the Bauhaus was considered "modern."

groundwork and teach at this innovative and—eventually—influential school. The main concern of this school was to blend art with industry. Craftsmanship was of prime importance, but so was beauty and function. In formulating this bond, certain criteria emerged that was found to be in all of the classical arts. This criteria was isolated, discussed, and written about. All of the arts shared these criteria that have become the designer's visual vocabulary. This basic concept of design has evolved with updated terminology, and sometimes with an aura of mystery attached . . . that only the "gifted artist" is able to understand these concepts!

Theory

Part of this mystery is because the study of design is a theoretical study. As in many theoretical studies, the theory and the result of the practiced theory may be a contradiction! What is a "theory"? A "theory" is the examination of information, often through a nonscientific analysis. From the information studied, a plausible statement is made—an assumption. I am sure you have heard the statement that a certain idea "is fine in theory, but it doesn't work in practice."

Some time ago there was an article in a newspaper about an airplane powered by microwaves. It was amusing because the plane only flew for a few minutes, but "in theory" it was supposed to be able to fly forever.

The THEORY of design is that if you know the elements and principles of design—*voilà! Magic!* We can design!

1–2
Ingredients for one kind of "scratch" (not in a box!) cake.

However, it takes some forethought and planning. We can dispel the mystery and also approach our ideas (or theories) of design in a systematic way, first things first. I have read design texts that give information about HOW to arrange the parts of a design, before students can identify the parts.

So, throughout this text, we will use the analogy of baking a cake from scratch (not using a cake mix from a box!) using basic baking ingredients. First we gather the ingredients, then we assemble the cake. The kind of cake we bake results from different methods of putting it together. In a like manner, different designs result from various ways of composing the elements. To quote a memorable teacher and artist, Robert Henri, "There is a certain common sense in procedure which may be basic to all."

Chapter 2

The Design Scene

Kinds of Design

The cars, electronics, clothing, and furniture that we so readily recognize as ever changing designs are classified as **functional**, or **product**, design. Product designs are items that our society uses in everyday life.

Another kind of design that is still a functional design is **graphic** design. This kind of design draws our attention to the product design. It is visual and usually gives people information for commercial purposes, such as advertisements.

A third kind of design is called **environmental** design, which still falls within the category of functional design. This kind of design deals with places where people live and work, like buildings or parks and gardens. It is often influenced by natural surroundings.

Fourth, there is the decorative *nonfunctional* design. This encompasses a wide range of arts—from crafts and photography to paintings. It is usually considered nonfunctional because it fills our emotional or aesthetic needs and is not considered a necessity.

Can these designs overlap? Let's think about these areas of design. Can you judge which category they fall into? Which ones overlap or are functional as well as decorative? What others can you name?

2–1
Our culture considers a refrigerator a "necessity."

BRIDGES	ADVERTISEMENTS	HAIRSTYLES
CLOTHING	PAINTINGS	DISHES
REFRIGERATORS	THRUWAYS	TEXTILES
NUTS & BOLTS	WINDOW DESIGN	POTTERY
TRANSPORTATION VEHICLES	WALLPAPER	??

Why are some things designed to satisfy our aesthetic needs? Do we *need* beauty to survive? It is believed that we humans would not have evolved to our current level if we had not considered these inherent needs. Beauty enhances the quality of our lives. True, beauty is also in the eye of the beholder, and what is beauty to one culture may not be beauty in another. But since early man, we have decorated ourselves and our environment.

Louis Sullivan, an architect, said, "Form ever follows function," which means that the best design solution will follow the primary need of the problem. Today's ski clothes, for instance, have become the best solution for skiers, providing ease, comfort, and protection from the climatic elements while practicing this exciting sport.

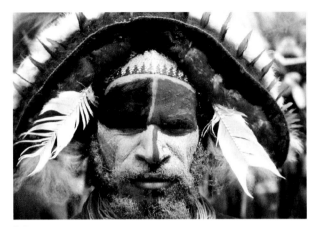

2–2

2–3

2–2
This painted face is a way of
beauty and perhaps identifica-
tion in this culture.
Painted face/Lake Kopiago/
Papua, New Guinea. Super-
stock, Jacksonville, Florida.

2–3
This column in San Francisco
is a structural support for this
building.
S. Brainard, photo.

The Role of the Designer

It's important to know the role the designer must play. As men-
tioned earlier, different kinds of design have different purposes. It is
often the intention of the fine artist to make social commentaries
through a work of art.

This may or may not be a positive, "pretty," or aesthetic comment.
It is, however, the **content**, and this message was the **intent** of the
artist. The viewer may indeed sense that feeling or emotions have
been exploited, or even violated. That is, perhaps, exactly what the

designer intended. The designer may have wanted the viewer to be shocked at what he or she saw and felt. If so, the designer was *successful!* Another artist may want the viewer to experience an upbeat mood, a feeling of lightness, warmth, or happiness. The design may be successful in extracting that response from the viewer—or the viewer may not give it a second look. In the first chapter we talked about the problems of the designer. While the fine artist may face the "problems" of mood or color as his or her objective, the designer of refrigerators has the problem of making the viewer stop, look, OPEN the refrigerator door, and make an evaluation about how this product would work in his or her kitchen, then consider the idea of purchase. The role of any functional designer is more restricted than that of the nonfunctional designer. There are very specific messages—or content—to often very specific audiences. For instance, adults buy refrigerators, so that message is not directed to children. Sometimes advertising is

2–4

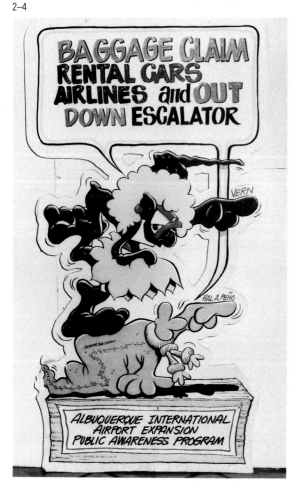

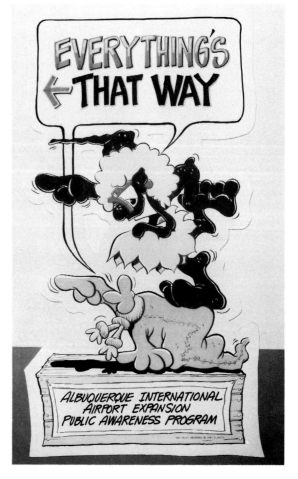

directed to children, so that they may coerce parents into buying a product. Sometimes communicating exclusive information is the primary responsibility of the graphic designer (see figure 2–4). Again, this is the CONTENT of the work. The INTENT is the idea of the problem and its solution.

Another thing designers must be aware of is being ORIGINAL. A friend of mine told me that when he was in college, his teacher

2–4
The designer has solved the problem of coping with frustration and confusion of maneuvering in a crowded airport during construction with humorous, but clear directions.
David M. Smith & Co. Albuquerque, NM. Temporary signage during construction of Albuquerque Airport. Courtesy: David Smith.

2–5
Ceramic blue and white goose-shaped water container for hubble-bubble. 17th century.
L.A. Mayer Museum for Islamic Art, Jerusalem, Israel.

2–6
The goose is the same image used in 17th- and 20th-century art forms.
Mariana Roumell-Gasteyer; Goose Teapot; white stoneware. Photo by Al Costanzo, Focus Advertising, Inc. Albuquerque, NM. Courtesy: Mariana Roumell-Gasteyer and Al Costanzo.

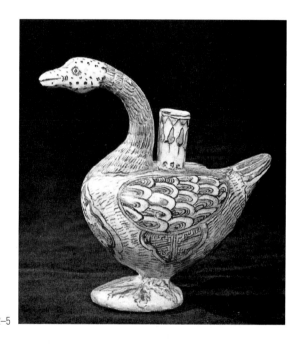

2–5

2–6

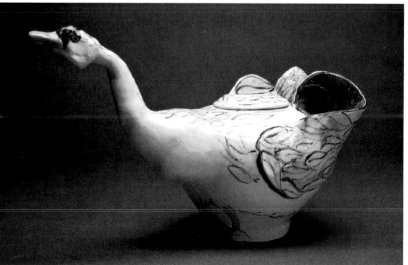

replied when he said he had no new subject to paint, "Yes, everything has been done, but not by you." This is so true. But beginning artists are often intimidated by this concept. So they hope that a "new" THING will appear magically for them to depict. There really are no new images or even new ideas! What may be new, however, are attitudes, tools, or media. Even the basic tenets of design and its components do not change . . . but the terminology may (a "tool" of communication)! So, even though an artist may be using an image or content that has been used for centuries, the way that idea or image is presented is what is new or creative and original.

Artist Eugène Delacroix said, "What moves men of genius or rather what inspires their work, is not new ideas, but their obsession with the idea that what has already been said is still not enough."

Are You Already a Designer?

Each of us gets up every morning, looks in the mirror, and asks ourselves: What am I going to do today? How am I going to function? Am I a businessperson sitting in executive meetings most of the day? Am I a college student going to classes all day? Am I getting married? Will I jog before I do anything else?

What we decide to do will determine our selection of the clothes we will wear. We will also probably choose clothes that we think look well on us, colorwise and stylewise. We dress according to what function we choose and try to look our best while doing it. We even think about how our hair should be arranged so that it best complements our features. We try, then, to present ourselves as a package, a total, a whole. We are the result of our clothes, hair, makeup, colors, and the like. We design *ourselves* everyday. Yes, we are already designers.

You have been introduced to: DESIGN
 COMPOSITION
 ELEMENTS
 PRINCIPLES

Do you remember the difference?

The parts:
SPACE SHAPE LINE TEXTURE VALUE COLOR
composed by using:
SPACE DIVISION BALANCE UNITY EMPHASIS
= THE DESIGN!

2–7
Line drawing of shoes.
What you will be doing will
influence your choice of
shoes to wear.

On the following pages, you will learn to identify the ELEMENTS in a SPACE and see how the PRINCIPLES have been used to compose or finalize the DESIGN.

Review

design	A visual, creative solution to a functional or decorative problem.
composition	The way the parts are arranged.
elements	The parts, or components, of a design.
principles	Ways the parts or elements are used, arranged, or manipulated to create the composition of the design; how to use the parts.
theory	The examination of information that often ends in a plausible assumption or conclusion.
functional design	Design that is utilitarian; necessary.
product design	The design of necessary, functional items in a society.
graphic design	Visual communication design for commercial purposes.

environmental design	Functional designs considering natural surroundings.
nonfunctional design	Design that is decorative or aesthetic. It is not strictly necessary to our functions as a culture.
aesthetic	A personal response to what we consider beautiful, often based on cultural or educated experience.
content	The message created by the artist. May be functional for consumer purposes; iconography.
intent	What the designer or artist intended with the design; may not have content or message.
original	A primary, inventive form of producing an idea, method, performance, etc.

Part

2

ELEMENTS OF DESIGN

Ch a p t e r
3

Space

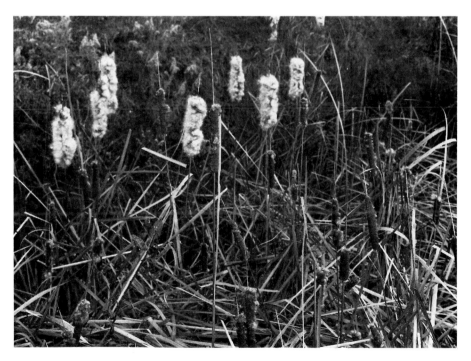

Before we begin looking at the parts, or ELEMENTS, of design, let's remember that we're studying some basic guidelines to help us look at what we see around us with an objective, more informed view.

Kinds of Space

Technically, space is not considered an element, but it is so essential to understanding the concept of design that I would like to think of it as a part of our whole.

The page before this one is empty. EMPTY, NOTHING, **negative**, SPACE. **Space** is where we start to solve our design problem. Even if we are designing a three-dimensional building or a sculpture with height, width, depth, and volume (or weight), we would use paper for planning our design. That paper is a two-dimensional space, having only width and height.

This two-dimensional space is called our **working space.** It gives us an idea where our limitations are—our boundaries. This working space often reflects what is called the **actual space.** The actual space may be a building lot for which an architect will design a house, several city blocks that will become a city mall, a portion of a magazine

3–1
Three-dimensional space (a foyer in a private home).
Douglas Richey, A.S.I.D. Interior Design.

3–2
The three-dimensional space is planned on a two-dimensional space.
Douglas Richey, A.S.I.D. Interior Design.

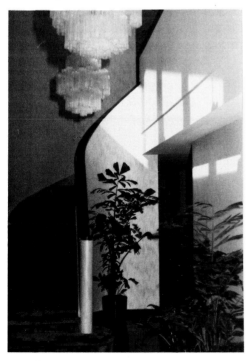

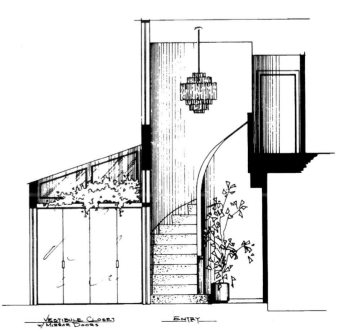

3–1

3–2

page where an advertisement may appear, or an empty canvas that will become a painting.

In order for us to fit our ideas realistically onto this space, our ideas have to conform to the space we have. If we are visual artists—such as painters or printmakers—we can pretty well choose our own space and create our own problem to solve: What do I put on this space now? But if we were that city planner with those city blocks, we must plan for *that* given space.

We need to know how much space we have . . . and what shape that space is.

The shape and direction of our space is called **format.**

If that empty page at the beginning of this chapter is looked at the way, or direction, the book is read, it has a **vertical format.** If you turn the book sideways, it would have a **horizontal format.**

We will talk about using two-dimensional design only, that design that is ORGANIZED on a flat surface with only height and width.

3–4 and 3–5
The same subject matter may
look different by the choice of
format.

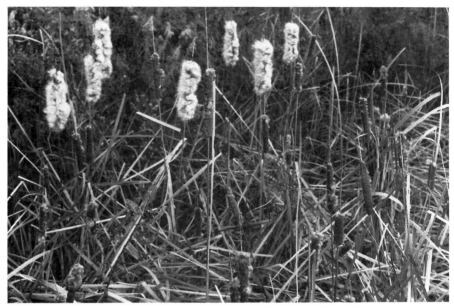

3–4

3–5

3–6
Gerald Brommer, WORK IN PROGRESS; Collage. Courtesy: Gerald Brommer from "Collage Techniques."

Let's Think About Space . . .

Why do we use a two-dimensional surface if we want to design a three-dimensional object?

What does FORMAT have to do with our design?

Is our working space ever our actual space? Give an example.

Why would a given or actual space affect our choice of FORMAT?

Would a "circular" format have a direction?

KEYWORD to remember: SPACE—an empty (NEGATIVE) area where our design will fit.

What Can You Do With Space?

What do you think your answer should be?

Can You Identify . . .?

the formats by direction or shape name?

3–7
Various formats.

Review

space	An empty, negative area where our design will fit.
negative space	Completely empty actual or working space.
actual space	The real space we have to fill with our design. This space has defined dimensions.
working space	The space that reflects the actual space. The two *may,* but not always, be the same space. This is the space we use to solve our design problem.
format	The shape and direction of our working or actual space. MAY BE HORIZONTAL, VERTICAL, ROUND, or the like.

Chapter 4

Line

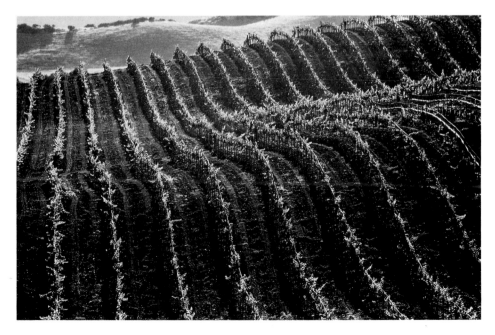

4–1
Line and pencil.

THIS IS A LINE

4–1

THIS IS A LINEAR SHAPE

What is a Line?

How do we describe a line? How does it differ from a shape? Can a line be a shape? Can a shape be a line? A **line** is a mark that is longer than it is wide and is seen because it differs in value or color from its background.

As small children, the first thing we draw on a piece of paper with a marker (or crayon, or pencil) is usually a squiggly line. What we experience then is the magic of seeing "something" appear on the paper.

A line is not usually thought of as a shape, but a shape can appear linear.

4–2
An example of linear shapes.
S. Brainard, photo.

4–2

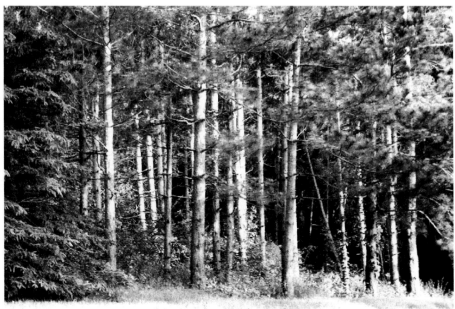

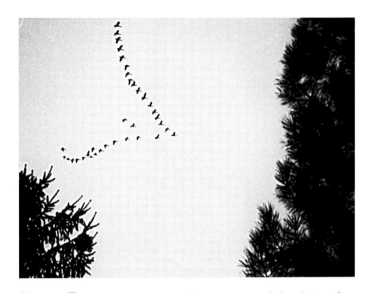

4–11
Geese in flight create an
implied V-shaped line.
S. Brainard, Photo.

Line as Texture. If you pull out one of the hairs from your own head
and hold it taut between the thumb and forefinger of each hand, you
see a line. Put millions of these lines together and you have hair—hair
that can be kinky, curly, straight, permed, and going in many direc-
tions. It has the sensation of something you can touch or feel. To
recreate this feeling of texture, you would have to study the hair or
lines, and watch the many different directions the hairs take individ-
ually. Many kinds of textures can be reproduced by the use of line.

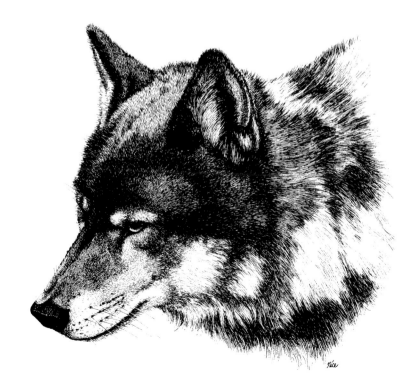

4–12
The play of lines creates the
texture of the wolf's coat.
*Claudia Nice, TIMBER WOLF.
Ink drawing. Courtesy: Claudia
Nice and Koh-I-Noor, Inc.*

Let's Think About Line . . .

When was the last time you used a line—in *any* way? What was it?

Did you create a boundary?

Did you follow a street sign?

Did you divide some kind of space?

Did you fly a kite?

Did you write or add figures manually?

Did you draw in the sand with a stick?

Did you make some shapes?

Did you plan a house?

Did you sew (either with a machine or by hand)?

What else did you do?

KEYWORD to remember: LINE—a long, thin mark, or images that make you *think* of long, thin marks!

What Can You Do With Lines?

You can make lines . . . THIN

THICK

LONG

SHORT

VERTICAL

HORIZONTAL

CLOSE TOGETHER

FAR APART

DIAGONAL

ZIGZAG

CURVE . . . AND WHAT ELSE?

You can use lines to . . . DIVIDE SPACE

MAKE SHAPES

MAKE SYMBOLS

DIRECT THE EYE
CREATE VALUE
CREATE TEXTURE
AND . . . ?
LINE IS IMPORTANT!

Can You Identify . . . ?

Lines?

Linear shapes?

How this photo makes you feel?

WHY?

4–13
*S. Brainard, Photo. Holland
Beach Boardwalk.*

Review

line	A mark longer than it is wide and seen because it differs in value, color, or texture from its background.
linear shape	An elongated shape that reminds us of line.
contour line	A line depicting the outer edge of a shape or group of shapes.
symbolic line	A line or combination of lines that stands for, or reminds us of, something within our realm of knowledge.
directional line	A line or lines which direct our visual attention in a specific direction.
boundary line	A line that confines our visual attention. It may serve to separate areas.
implied line	A perceived continuation of images or symbols that imply a line.

Chapter
5

Shape

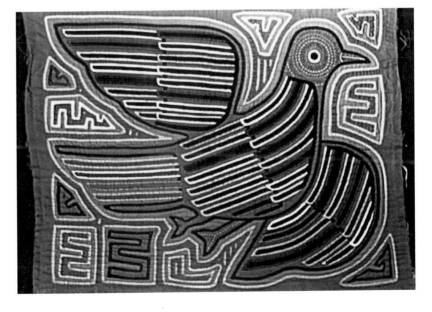

What is a Shape?

A **shape** is an image in space. This shape may or may not be recognizable.

Babies see an undefined blur that changes to a face with color with a voice that is eventually recognized as a sound that goes with this "shape."

Later, when we are older, someone gives us a crayon and some paper and with those lines we start to draw our small world (remember those lines in the last chapter?). We hook the lines together and they turn into shapes that become someone who is important to us— Mama, the cat, or "Jimmy" (an imaginary friend). To us, the shape we put on our paper is who or what we say it is. The *drawing* of Mama, however, is what becomes the subject of the day, not Mama herself. The family is proud of the drawing, and *voilà!* An artist is born! It does not matter that it is not an exact duplication, or even a near representation, of Mama; it is the essence or the symbolism that has become important.

It is hard for us to accept this symbolism. Why has Picasso's work been so difficult for people to accept? Because it is ugly? We have trouble with Picasso because his faces do not seem like faces we *know*. As we grow older, realistic or representational shapes seem to become more important to us than symbolism.

5–1
"Jimmy Dressed as a Carrot."
"Jimmy," although invisible to others, was visible to my son.
*Evan Brainard, Drawing
(four years old)*

There is a paradox here.

As we enter the years of curiosity, experimentation, and rebellion, why don't we reject the *images* that are familiar to us the way we turn against other familiar things, like our dress, our behavior, or the food we eat? Why don't we experiment with images the way we experiment with other things in our new grown-up life? Instead, we cling to the traditional, to the familiar shapes of "things" we *know*.

"Things" are used as sources for kinds of shapes, and the original meaning of the "thing" is no longer as important as the found shape.

Kinds of Shapes

This is a "rose." We know it as a "thing," an object we all recognize. We are now going to try and think of this rose as a **shape**, a source for other shapes, shapes in space.

The rose (an identification title only) can be the source for many kinds of shapes that the design world puts into categories. One such

5–2
A rose is a natural shape—or a shape found in nature. *"Chicago Peace" rose. Courtesy: Jackson and Perkins.*

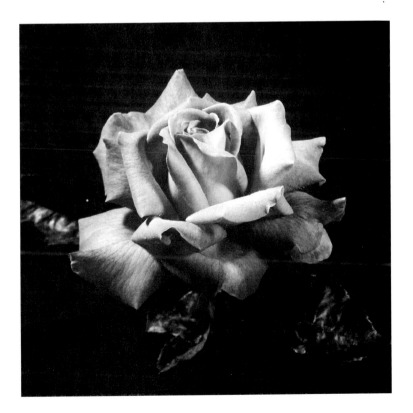

category is **natural shapes**—shapes as we know them in their natural state, or from the world of nature. These are familiar to us. In other references, you may see them called organic or biomorphic.

These shapes can be altered, simplified, distorted, enlarged, half-hidden . . . anything that changes them . . . and their subject may still be recognized; the essence remains. They are then called **abstracts**, or "abstracted, pulled from" the original.

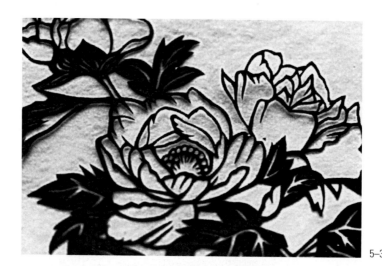

5–3

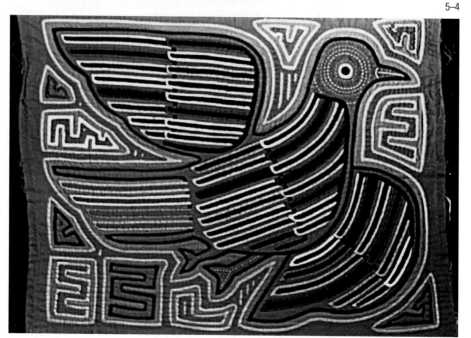

5–4

5–3
This rose is seen as a rose, but is not "realistic." It is slightly abstract.
Artist unknown. Chinese paper cutting. Collection of the author.

5–4
An abstract shape of a bird using geometric shapes.
Unknown artist, the "mola" is an art form of reverse appliqué indigenous to the Cuna Indians of San Blas, Panama. Courtesy: Nyla Ridenour.

6–2
A painting done in color but translated into values expresses a range of value planning.
Mark Mehaffey, FLOWER FORMS #4. Transparent watercolor and acrylic wash 47" × 57", 1989. Courtesy: Mark Mehaffey.

visual effect of the third dimension: that of depth and weight on a two-dimensional surface. Values are important in the creation of a three-dimensional effect, because without "shading" to round out our shapes, they would appear flat. But often, we use flat shapes and *want* them to be flat. We would still use contrast in the "push-and-pull" of one value against another to distinguish one shape from another. When we are using gradual value changes to create this three-dimensional effect, it is crucial not to jump quickly from one value to another. This use of values is more prevalent in the fine art field of design than in the field of functional design.

6–3
A circle with no values or "shading," looks flat, having no volume, or depth.

6–4
The same circle with added values makes the round shape appear as a sphere.

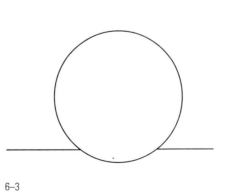

6–3

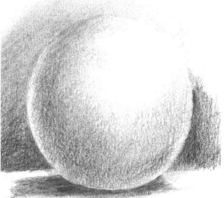

6–4

6–5
Adding values gives the head
a three-dimensional effect.
*Kalon Baughan, MALE FIGURE.
Drawing, Graphite on paper
18" × 24", 1987. Courtesy:
Kalon Baughan.*

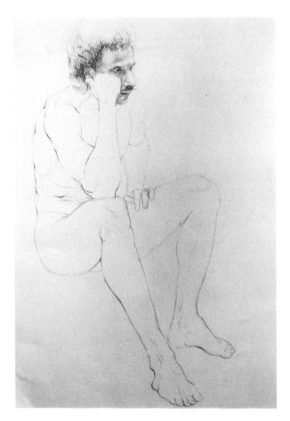

The portrayal of values plays an important role in evoking certain responses from the viewer. We may want the viewer to perceive a special effect, like an emotional response, by the use of somber, darker values for the shadowy sides of life; or light values for the upbeat parts of our lives. Sometimes we may contrast these values to create emphasis, or to feature something else in the design which needs the attention.

What often seems like a contradiction in the portrayal of representational still lifes or landscape drawing and painting is the special effect of depth or distance. We use darker values to create *depth,* but lighter values to create *distance.* Is there a difference? Depending on the subject matter involved, and recognizing particular shapes in the foreground, a dark value can create the perception of depth, or a "measurable distance down or into" a space. In other words, we can make a shape on a surface look as though it goes *into* and *beyond* that surface—or into a "hole"! Conversely, lighter values used in the background of a landscape gives the viewer the sense of greater space in

terms of mileage. Darker values are usually used in the foreground to sharpen the details of the foreground.

The use of values is often misunderstood by the novice student. Values are the most intimidating of the elements. In beginning drawing, the student tends to make drawings too light, while the beginning painter usually uses colors that are too dark!

6–6
Dark values can indicate depth.
S. Brainard, Photo.

6–7
Light values can achieve the visual effect of distance.
S. Brainard, Photo.

6–6

6–7

Let's Think About Values . . .

Do values add interest?

Do value contrasts apply only to representational work?

Do you know how to evaluate one value against another?

Can you evaluate value differences?

What would happen if very close values were used in one design?

KEYWORD to remember: VALUE

What Can You Do With Values?

Values Can Be Used: TO CREATE A CONTRAST

TO ADD INTEREST

TO CREATE A VISUAL FEELING OF VOLUME, OR A THREE-DIMENSIONAL EFFECT

TO CREATE VISUAL DEPTH

TO CREATE VISUAL DISTANCE

TO CREATE EMPHASIS

TO CREATE A MOOD

Can You Identify . . . ?

the differences in value between the two photos of bulbs in figure 6–8 and 6–9 on the next page?

Why does the difference in value make a difference in the way you see the photos? What you would do to correct either one?

Review

value The range of possible lightness or darkness within a given medium.

medium The kind of material(s) one is working with, such as pigments, film, fabric, pencil, steel, and the like (plural—mediums).

relativity The degree of comparison of one thing to another. How does *a* compare to *b;* then what is the comparison of *a* to *c.*

contrast The result of comparing one thing to another and seeing the difference.

6–8 and 6–9
S. Brainard, Photos. BULBS.

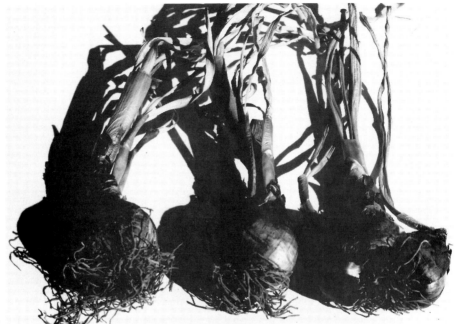

6–8

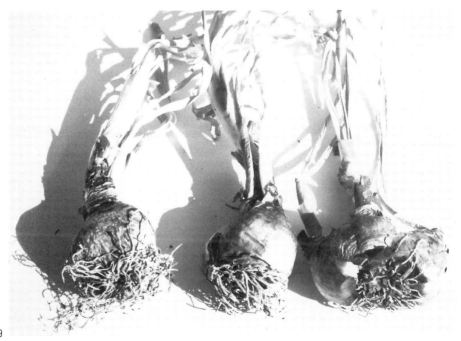

6–9

Chapter
7

Texture

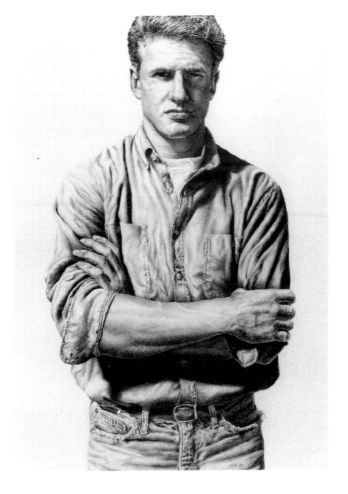

What is Texture?

Texture is a simulated tactile surface. It is the easiest element to describe because it is a visual surface quality.

We are familiar with real texture, that which we can *feel* or that which is *tactile*. The element TEXTURE in two-dimensional design is a visual sensation but mentally interpreted as tactile. So let us identify TEXTURE as a **simulated tactile surface**. We make a surface *look* either rough or smooth as if we can feel it.

Look back at figure 4–12. Can you *feel* the coat of the animal?

7–1
Textures contrast with one another, rough and smooth.
S. Brainard, Photo.

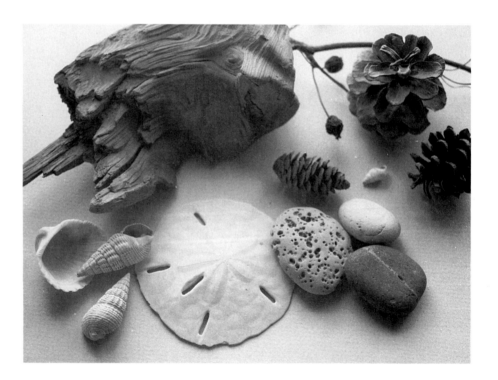

Rough or Smooth?

Texture is often thought of as something that is rough only, or has a structural feeling. But a smooth surface is also a texture.

Think of all the rough surfaces you can feel. Think of the smooth ones you can feel. What kind of textural sensations do you have when you eat? What can you think of as rough-against-smooth textural contrast?

Textures can be created in many ways, the most common by using contrasting lines or values, directional lines, shapes placed close together, or rubbings from actual textural surfaces.

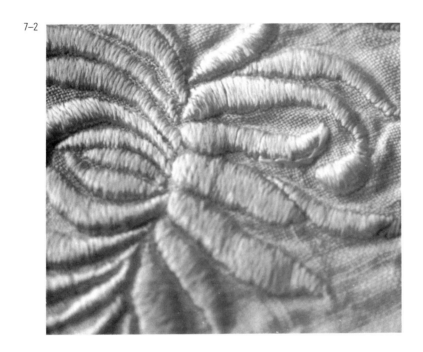

7–2

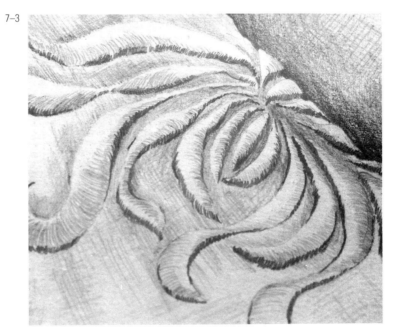

7–3

7–2
Embroidered linen cloth, Collection of the author. The embroidery stitches create a raised surface which contrasts with the weave of the linen cloth. *Artist unknown.*

7–3
Pencil Drawing (detail). Simulated texture based on the embroidered cloth. *S. Brainard, THE GIFT.*

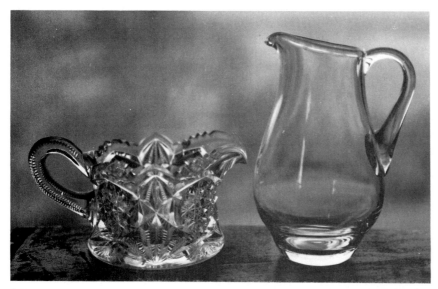

7–4

7–5

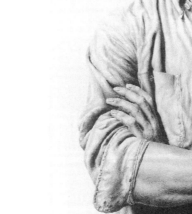

7–4
Two pitchers—both glass—
show contrasting surface
textures.
S. Brainard, Photo.

7–5
Note texture of hair, skin,
muscles and worn jeans.
Kalon Baughan,
SELF PORTRAIT, Drawing,
graphite on paper.

Can You Identify . . . ?

By its visual quality, can you identify what each of these common ten textures represent?

7–6
S. Brainard, Photos: Textures.

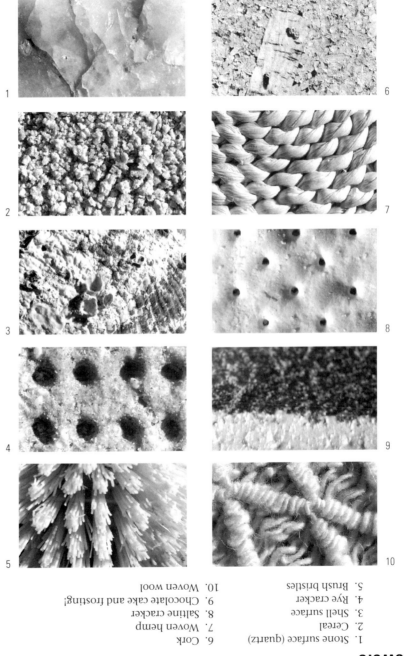

Let's Think About Texture . . .

What are some TEXTURES you like?

Ice cream?	Leather?
Satin?	Chocolate cake?
Corduroy?	A new car?
Brick?	Fur? (This could be your pet friend!)
Raw liver?	Your hair?
Yarn?	Someone else's hair?
Polyester?	Cut glass?
Plastic?	Wood?
Plants?	A pine cone?

KEYWORD to remember: TEXTURE—simulated tactile appearance.

What Can You Do With These Textures?

Can you depict them visually?

Can you do any of these simulated textures by using *real* textures, and do something like rubbings?

Can you do rubbings and have others identify the source?

Review

texture	The quality of being tactile, or being able to *feel* a rough or smooth type surface.
simulated texture	The real quality of a tactile surface being copied or imitated.

C h a p t e r

8

Color

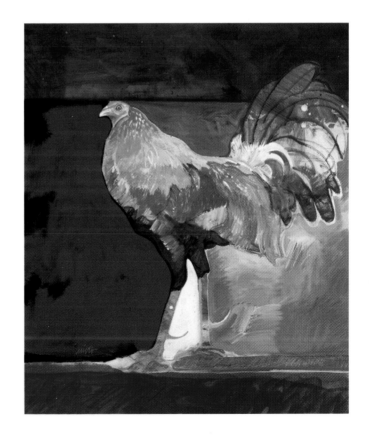

What is Color?

Color is EVASIVE—
CONTRADICTORY
BEAUTIFUL
SENSUOUS
RELATIVE
DECEPTIVE
CONTRARY
LOVELY
FUN
LIVELY
MYSTERIOUS
AND . . .

PULCHRITUDINOUS!*

*The ultimate in beauty.

Whole books have been written about color: What it is; what it isn't; comparative analyses; what colors look good with what other colors or color harmonies; how colors affect us mentally, emotionally, and even physically. Color has been used to soothe us, excite us, and label us. The *use* of so many colors is mind-boggling. But we must remember, when speaking of the basic rudiments of design, that *color is another element!* It must be considered as one with the other elements and used as the other elements are used.

Many academic design courses are separated into two areas: DESIGN Theory and COLOR Theory. In this book, we will keep color in perspective, and consider it as only WHAT is necessary in the practice of design.

**COLOR IS NICE, BUT, AS FROSTING ISN'T NECESSARY
TO A CAKE, COLOR ISN'T NECESSARY TO A DESIGN.**

Most of us had a color wheel in our first-grade room in elementary school. This was probably our introduction to color, and we were told that yellow, red, and blue combined to make all the other colors.

Then, later in science class we were told that light made color, and

we were shown pictures of sunlight going through a little triangle called a prism, resulting in a rainbow.

I don't know about you, but I was confused!

I thought a lot about theories . . . like, "If a tree fell in the woods would there be a sound?"—OR—"If the light goes out is there still color?"

We now know a lot more about color than we used to know, thanks to the sciences. We know that the physical and natural worlds work hand-in-hand so that we humans can experience the marvel of color.

Let's look again at that prism. This color mixture is the product of light. As the light—light that is produced by the sun—passes through

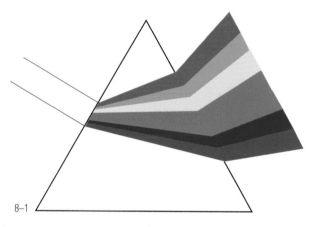

8–1

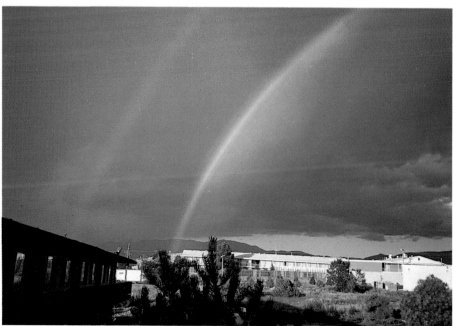

8–2

8–1
A visual spectrum created by white light which has been broken (or refracted) by entering a prism. *(Plate 4.6 design by Philip Rawson, p. 114.)*

8–2
A double rainbow displays nature's spectrum—twice! *S. Brainard, Photo. MOTEL6-POT-O-GOLD*

the prisms of nature, as beams of light passing through drops of moisture and dust particles, they are broken up or "diffracted" into different wave lengths, or graduated bands of color. This is called a spectrum or, when viewed in its entirety reflected in the sky, a rainbow.

This mixture of color is called an ADDITIVE mixture.

The science of physics explains it as the addition of one light color vibration to another; the more color that is added, the more light you have.

8–3
A glass prism hung in a window gives us "rainbows" on our walls.
S. Brainard, Photo.

In the 1660s, Sir Isaac Newton (of "apple dropper" and law of gravity fame) also experimented with glass prisms, allowing light to pass through and split up into a range of colors, therefore documenting a physical phenomenon. Today, many of us hang tiny glass prisms in our windows, producing little spectrums that dance and play on our walls on a sunny day.

Nature produces pigments, substances that impart color to objects or materials. Every living thing has an *internal* pigmentation. There is

"chlorophyll" in green plant life, "carotene" in carrots, "anthocya-nine," which produces our red leaves in the fall, and "melanin" in humans, which determines our skin color. These are only a few examples. Sometimes nature goofs with the percentage of pigmentation assigned, and a mutation occurs. Then an animal or person may lack a degree of color and be very light or even white. This is called an *albinism,* or the state of being an albino.

8–4
A lack of pigmentation.
Albino Gorilla/Barcelona Zoo, Barcelona, Spain. Superstock, Jacksonville, FL.

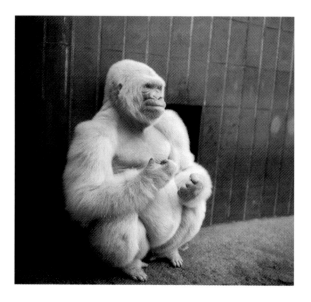

Humans make another pigmentation, a coloration put on the *surface* of things. This is an *external* pigment. This is usually derived from natural sources or artificially produced in laboratories. Paints, chalks, lipstick, crayons, and eye shadow are a few of our external pigments. This color mixing process is the result of one color's exerting its force on another color. The essence of each original color is cancelled or *subtracted,* and something different from the two originals is produced. This production of pigments or color mixture is called a **subtractive** mixture.

Let's look at how the two worlds work together.

Sunlight goes through atmospheric prisms, splits up into rays, and hits an object which is green because of biological pigments like a tree. Each object reflects its own color and absorbs all others from the light it is reflecting. The *green* is reflected back to us and is what we see.

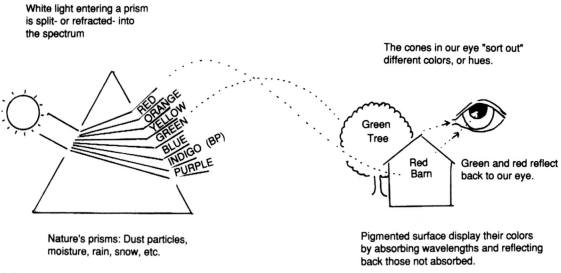

White light entering a prism
is split- or refracted- into
the spectrum

The cones in our eye "sort out"
different colors, or hues.

RED
ORANGE
YELLOW
GREEN
BLUE
INDIGO (BP)
PURPLE

Green
Tree

Red
Barn

Green and red reflect
back to our eye.

Nature's prisms: Dust particles,
moisture, rain, snow, etc.

Pigmented surface display their colors
by absorbing wavelengths and reflecting
back those not absorbed.

8–5
Diagram: How we see color.

The easiest way to explain this is that color is the reflection of light from a pigmented surface, which, through the eyes, is transmitted to the brain. Color is a sensory, not physical, experience. It cannot be touched or felt, except psychologically. This is why we respond to color in various ways.

NOW—*what happens if* there is a barn that a human has built and painted red next to the green tree—and a yellow flower—and . . . ?

The world is filled with hundreds—THOUSANDS—of colors, and we see them all at once. HOW? Through another wonder of nature—OUR EYES!

Our eyes have about 6.5 million cones that take in and sort out various color sensations and send color "messages" to the brain. We have approximately 100 million additional rods that take in and sort out darks and lights. Both are photoreceptors that help make up the retina of the eye. This "sorting-out" process is unbelievable—but true. Our cones sort out the green tree, the red barn, the yellow flower, and the pink flamingo! The rods tell us whether the green is dark green or light green, the flamingo pink or red.

It will be easier to remember color production if we remember these two color mixtures. As electricity is a substitute for the sun, graphic computers, color television, and theatrical lights all use color produced by the additive method. Surface coloration, which is manu-

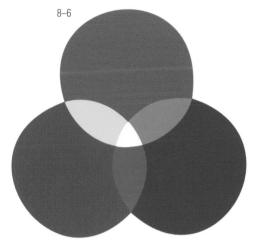

8–6

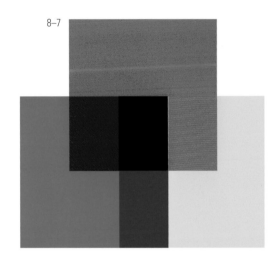

8–7

8–6
Example of *additive* color mixing.
(Plate 4.8 Design, by Philip Rawson, p. 114.)

8–7
Example of *subtractive* color mixing.
(Plate 4.9 *Design,* by Philip Rawson, p. 114.)

factured using natural or artificial pigments, uses color produced by the subtractive method.

ADDITIVE = LIGHT MIXTURE
SUBTRACTIVE = PIGMENT MIXTURE

Color Wheels

Newton, busy man that he was, also arranged the spectrum band into a circle to study the colors. Many color wheels have been developed since Newton's. A **color wheel** is no more than a visual method of charting colors for reference. Most are based on the use of the **primary** or first colors found in the color mixes. Research done in color laboratories has succeeded in recreating light mixtures, isolating pigment components, and experimenting to find the primary and **secondary** (second) colors for each.

A PRIMARY COLOR CANNOT BE PRODUCED BY MIXING TWO OTHER COLORS, BUT, THEORETICALLY, PRIMARY COLORS CAN PRODUCE THE OTHER COLORS.

In the light mixture, it was found that red, green, and blue were the primaries; with yellow, cyan (a greenish-blue), and magenta (purplish-pink) as the secondaries.

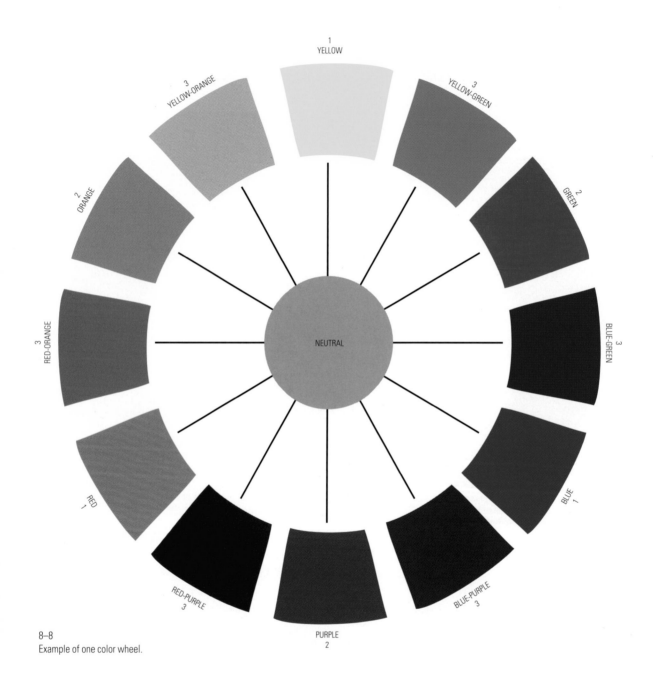

8–8
Example of one color wheel.

In the pigment mix, yellow, blue, and red are the primary colors, while green, purple, and orange are the secondary colors.

A SECONDARY COLOR RESULTS FROM MIXING TWO PRIMARY COLORS.

The subtractive color wheel, defined by Herbert Ives (after Newton's) is the one we knew in grade school. Because it is familiar and easy to use we will use this wheel for reference in the rest of this chapter on color. All the other information or theory regarding color pertains to all color mixtures.

The combination of the primary and secondary colors are the **tertiary** (third) colors you see on the color wheel.

So let's look at our color wheel. The primaries are yellow, blue, and red; the secondaries are green, purple, and orange; while the tertiaries—sometimes called "intermediates"—are yellow-green, blue-green, blue-purple, red-purple, red-orange, and yellow-orange. Notice the primary color is named first.

IMPORTANT TO REMEMBER: *color wheels are only reference charts.* We now know how color is produced, how we see it, ways to chart it, and the basic colors.

The colors on the color wheel are *technically* called **hues.** COLORS are usually made from changes to these basic hues, OR from the actual pigmented source. But, we do not call these charts "hue charts"! (It is not uncommon to use the two words synonomously.)

Color Identity

How do we identify all the colors we see?
There are three major properties to each color:
HUE
VALUE
INTENSITY

Let's try and define each.

Hue. **Hue** is the pure state of a color. A pure hue means the hue has not been changed or altered from its original state; it is virginal.

The easiest way to remember hue is that it is a family with a family name. All the names given a hue such as blue, like "Periwinkle," "Navy," "Cornflower," "Royal," "Indigo," or " Blueberry," tend to describe something in our experience, that we are familiar with, and that we can identify with. They bring to mind an object with a close facsimile to the color. Each color has many variations. Hue is the same as a family name like "Smith." How do you distinguish one Smith from another? *By first names.* John Smith and Marsha Smith are not unlike Navy blue and Baby blue. Names of colors tend to be

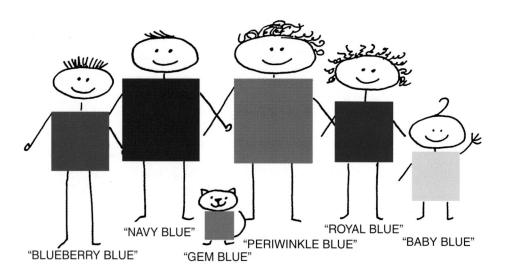

"NAVY BLUE"

"ROYAL BLUE"

"BLUEBERRY BLUE"

"PERIWINKLE BLUE"

"BABY BLUE"

"GEM BLUE"

fads, usually because of retail businesses, and a color may be one name one year and another name ten years later.

However, the names given to colors help us to mentally describe and identify the colors. Can't you mentally tell the difference between "Raspberry Red," "Cherry Red," and "Burgundy"? So we will learn to identify colors in a more academic way, using the three parts of a color's identity. To simplify, we will say that the colors on the color wheel represent families—twelve families that we will get to know.

Value. Value is the range of darkness or lightness of a color. Values relate to color the same as do the white-to-black values that we studied earlier. A high value of a color is one closer to white, while a low value is closer to black. Value has to do with HOW MUCH LIGHT—or quantity of light—we see on a color. If our green tree and red barn are observed at dusk when there isn't much light available, they may appear dark green and dark red.

When mixing pigments, *to change the value of a color* we add black to make it darker, white to make it lighter. If it is a darker color, we call it a **shade**; if it is lighter, we call it a **tint.**

We can now have dark hues, medium-dark hues, medium, medium-light, or light hues. We would say "a high value blue" for light blue.

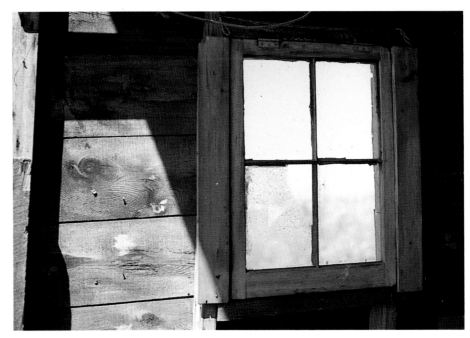

8–10
An example of dark and light
values on colors.
S. Brainard, Photo.

Intensity. **Intensity** is the brightness or dullness of a color. This brightness or dullness has to do with the *kind* of light—or *quality* of light—a color receives. On a bright, sunny day, colors will appear brighter than on a dull, dismal day. Our green tree and red barn at dusk would look dark and *dull* if it were a rainy evening. But just because a color is dark DOES NOT MEAN IT IS DULL, nor is a light color always bright.

A hue in its pure state is at its brightest. The colors on the color charts are pure hues. A color cannot be made brighter than its pure state. It can be changed to darker, lighter, or duller.

When a color is at its brightest, it is called HIGH **intensity.** When it is dull or grayish, it has a LOW INTENSITY.

The degree of color purity can be decreased in pigments in three ways. One is by dilution, such as watercolor. As more water is added to the pigment, the solution weakens and the color becomes less intense. This is like adding a lot of water to a cup of coffee to make two cups of coffee: The intensity of the color of the coffee, as well as the flavor, has been reduced.

8–11
A color value chart depicting
the same color altered by the
addition of white or black to
make shades.

8–12
This photo of cottonwood leaves shows a range of *tones* or a scale of bright to dullness of the leaves' colors. At the lowest range, the color becomes a neutral (a brownish color) and is also darker in value.

The second way the purity of a color can be decreased in pigments is to add gray, a combination of black and white. If you add a *light* valued gray, the result will be a light, dull color.

The third way to decrease color purity is by adding the color's complement. What is a complement? Let's look at the color wheel again.

The color directly opposite any selected color on the wheel is called its **complement.** This is important information to remember, as complements will be referred to many times in the study of color.

If we choose blue as our color, the color opposite is orange. Orange is the complement of blue. So adding a touch of orange to our blue will LOWER THE INTENSITY of the blue, making it duller. It may also make it a tad lighter! DO YOU KNOW WHY? Look at the *value* of blue. It is darker than orange. The orange being lighter in value will bring up the value of the blue. WE ARE SPEAKING OF COLORS IN THEIR PURE STATE—PLAIN OLD BLUE AND PLAIN OLD ORANGE.

Sometimes colors are dark . . . and bright!

Sometimes colors are light and dull!

Sometimes colors are medium and medium!

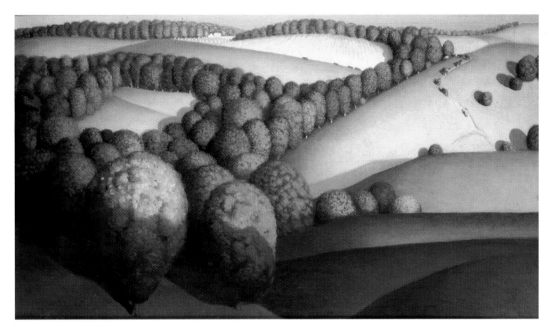

8–13
High values, low intensity colors are depicted in this painting. *Grant Wood, NEAR SUNDOWN, oil on canvas, 38 × 66 cm. Spencer Museum of Art, University of Kansas: gift of Mr. George Cukor.*

Marc Chagall said, "All colors are the friends of their neighbors and the lovers of their opposites."

Let's refer to our color wheel again. I recommend that we use the color wheel with the yellow at the top and purple at the bottom. We have a reference not only to the hues, or families of color, and their relative purity—and in this pure state they are all equally bright—but also to their relative values. The yellow at the top is, in its pure state, the lightest hue, with yellow-orange and yellow-green (on either side) a bit darker than the yellow, until as we go down the wheel laterally we come to purple, which is the darkest.

Do you remember seeing a gray circle in the middle of that grade school color wheel? That gray represented **neutral**, or what you get when you mix complements together. The thing is, you *never* get gray, you get a "grayed" or dull color—a **tone**.

What does neutral usually mean? That it isn't this way or it isn't that, it's in the middle! This is what a neutral is in colors also. When we use our complement to lower the intensity of a color to the point that neither color is evident, but the mixture is something in between, it is neutral. Our blue, for instance, with enough orange

8–14
A color intensity chart show-
ing how the same hue can
be altered to make *tones:*
by the addition of grays or
by the addition of the hue's
complement.

added, wouldn't be blue, but it wouldn't be orange either. It would be neutral.

Many colors we know are colors made from neutralizing colors. "Brown" is the lowered intensity of orange, while "khaki" is the lowered intensity of green. Our tans, beiges, taupes, and so on are all neutrals. (These colors may also come from natural pigments.) A technical explanation of gray is that it is produced by mixing a black and white pigment. Gray is achromatic, or without color.

Let's remember: *Intensity is the brightness or dullness* OF A COLOR. IF THE INTENSITY HAS BEEN MODIFIED, IT IS A *tone*. IF IT HAS BEEN CHANGED TO THE POINT OF NO RECOGNITION (by its complement), IT HAS BECOME A *neutral*.

There are many colors of one hue. For instance, there may be ten natural sources for a blue pigment. We can add them all into our original family. Then we can change all those blues by value and intensity, and we begin to see how many colors are possible within one family. Then we can mix some of the blues together and get still different blues, and then changing the value and intensity of those blues . . . WOW!

Color Temperature. I am of the opinion that there is a fourth important identification that should be learned about here, and this fourth identity is **color temperature.**

When we speak of a color being WARM or COOL, we're not referring to an actual physical quality of the color, but an emotional or aesthetic quality. However, when we *experience* actual heat or cold, the colors we associate with either can help us. HOT or WARM reminds us of fire, or sun—red, yellow, orange—but also the bright blue of a very hot flame. These colors are usually *bright,* with perhaps a medium or even dark value. On the other hand, COLD reminds us of ice, snow, or gloomy days that make us feel cold. These colors of association are usually light, maybe white, and—*perhaps* dull.

We have been taught that the colors on the color wheel—red-purple through the reds, oranges, and yellows to yellow-green—are considered "warm"; while starting with green through purple are the "cool" colors.

8–15

8–16

8–15 and 8–16
Temperature Charts.
(Plate 2.21, Theory
and Use of Color,
Luigina de Grandis,
p. 35.)

HOWEVER—each color has its own degree of warmth or coldness as a *pigment.* Remember those ten blues a few paragraphs back? Blue is supposed to look cool. Why, then, does one look warm? The degree of apparent "visual" warmth or coolness depends not only on the individual pigment, but also on WHAT OTHER COLOR IS PLACED ALONGSIDE IT. Our blues will all look cooler next to yellows—right? WRONG! If a blue's value is darker and its intensity very bright, and if the yellow's value has become almost white, the yellow will appear cooler!

It takes close observation over time to see these variances. For safety's sake, let's remember the following *usual* temperate appearances:

WARM—HOT = Bright (high intensity)
Medium to dark value
COLD—COOL = Medium, low intensity
High value

8–17

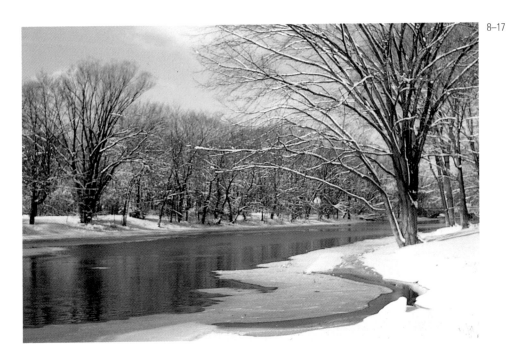

8–18

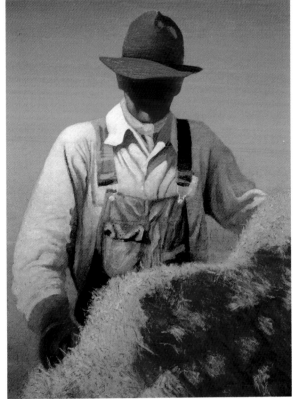

8–17
This winter scene makes us feel cool, because of what we know about winter and the colors associated with coolness. *S. Brainard, Photo. WINTER.*

8–18
What kind of temperate feeling do you experience looking at these colors? *Gary Ernest Smith, MAN WITH STRAW BALE. Oil on canvas, 48" × 36". Courtesy: Overland Trail Gallery, Scotsdale. AZ.*

Color Perception

This is a good time to discuss **perception**, which plays a HUGE part in color. The viewer's—as well as the designer's—perception of a given color may vary a little, or a lot.

Perception has to do with stimuli to our senses. It also has to do with what we were exposed to as we grew up.

Let's think about our chocolate cake again. In our western world, and especially in the United States, chocolate cake is very common! In some countries, however, people may be well acquainted with chocolate, but *not* with "cake." If I hear "chocolate cake" or see a picture of a chocolate cake, it evokes a taste and smell sensation—and I want some! However, if we have never had a piece of chocolate cake, then this doesn't work. It doesn't mean that we can't acquire a taste for it—we can . . . and probably will.

If we have never been exposed to a wide variety of experiences, we have a limited number of comparisons. If we've been taught one thing and lived with that information for many years, it is sometimes difficult to quickly adapt to new ideas. This often happens with color. If we haven't developed an awareness of many color variations—(and we do take colors for granted)—it can be very hard to "see" the differences in 20 different blues.

This often occurs in the classroom as we try to identify colors by "hue, value, intensity, and temperature." Some of us will catch or perceive any slight nuance of modification, while others may be able to tell only one or two changes.

But it can be learned, so don't worry. Again, time and practice are the keys.

We could describe one blue from another in this way: "blue hue, medium value, high intensity, and warm," while its partner may be "blue hue, high value, medium-low intensity, and cool."

See how many colors of one hue you can identify in this way. In my classes, we have a BLUE-DAY or RED-DAY and we all wear the same hue. VERY INTERESTING!

Color Interaction or "Those Lying Colors"

We have been thinking of comparisons. We NEVER see one color all by itself. There are always other colors around it, and so one color always relates to another.

Color Is the Most Relevant Element. Its behavior will change with its environment!

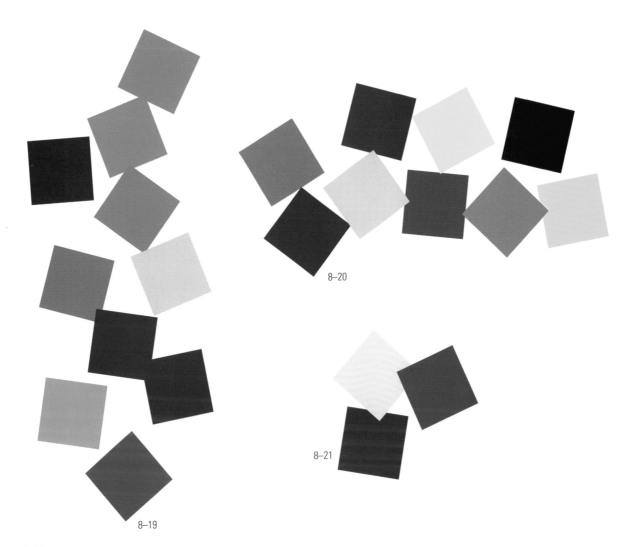

8–20

8–21

8–19

8–19
Example of blue pigments
(all blue hue) in their pure
state. Does one look warmer
than others? If so, *why?*

8–20 and 8–21
A color's behavior depends
on the colors around it.

This is very sneaky and deceptive!

You may see a color that looks bright blue, and along comes another blue and the first looks like a dull . . . green? Or what about that red sweater you bought that you just *knew* would go with your red plaid skirt? That sweater looks absolutely ORANGE! So, you'll wear the sweater with another plaid skirt which had blue-green, rust, and orange in it. Now the sweater looks RED! We spoke of similar comparisons when talking about color temperature, variations of colors, and the like. It happens all the time!

8–22

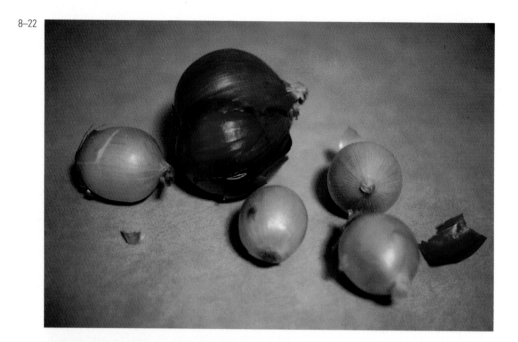

8–23

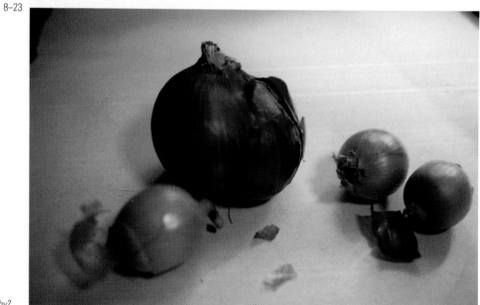

8–22 and 8–23
The same onions with
different backgrounds.
Which appears cooler? *Why?*

All of these comparisons have to do with the interaction between colors, and this is why color can be deceitful.

Think how you would feel if you owned a successful neighborhood meat market and had had the same reliable customers for years. Your

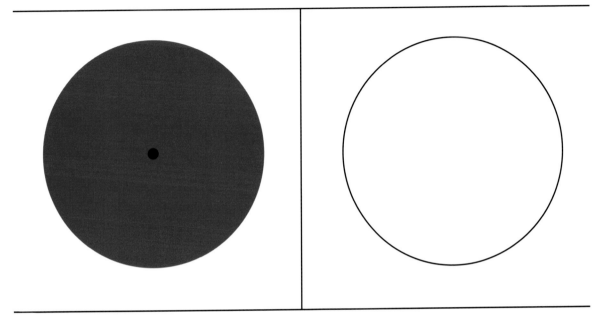

8–24
Stare at the black dot on the red circle for a full minute—then shift your eyes to the white circle. *What do you see?*

shop has been painted a sterile white all this time and is showing its wear, so you decide to do a little redecorating. Reading somewhere that yellow was a cheery color, you paint your interior a nice, bright yellow . . . and slowly, but surely, those loyal customers of yours leave your store without buying, and many never return. WHY? It was found that the yellow walls made the meat look . . . PURPLE! A "color-fairy" comes along, whispers in your ear to paint the walls a nice "mint" green, and PRESTO! your business shoots upward again!

In human psychology or color consulting, this is a common story. The experience is called seeing an "after-image," and it happens after we have consciously, or unconsciously, stared at a color for a length of time—as we would be apt to do standing in line at a grocery counter. When we suddenly look elsewhere, we see the *complement* of the color we were looking at, often in small geometric shapes.

What is important to realize is that unusual things can and do happen with color, and we should plan for those unexpected events. As a painter myself, I often "mentally" paint while driving, before I physically pick up my brush. We all do masterpieces in our heads, but then it often doesn't come off! When faced with such a failed masterpiece, we have to analyze the basic design, the color, see WHAT went wrong, and make corrections.

The control of color—and good color usage is control—comes not

only from the choice of colors we use, but, as with the other elements, HOW we use them. We have to be careful how our colors act and react together; we must plan their contrasts.

We talked of contrasts in the chapter about value. Remember high contrasts and low contrasts? With color, there are four major contrasts, and the capable colorist will carefully consider color placement. Let's look at the contrasts:

DARK/LIGHT—BRIGHT/DULL— WARM/COOL—LARGE/SMALL

Dark/light is the relative contrast between values of colors. This could be a dark red to a light yellow; a dark red to a light red (which could be pink); or a dark neutral to a light red.

8–25
Dark/light contrast.
S. Brainard, Photo.
JAPANESE GARDENS.

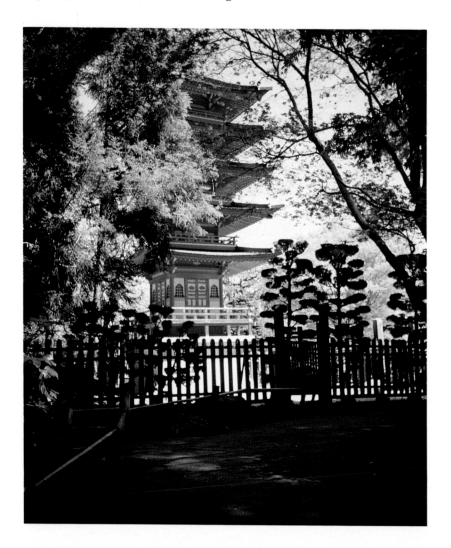

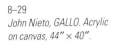

8–29
*John Nieto, GALLO. Acrylic
on canvas, 44" × 40".*

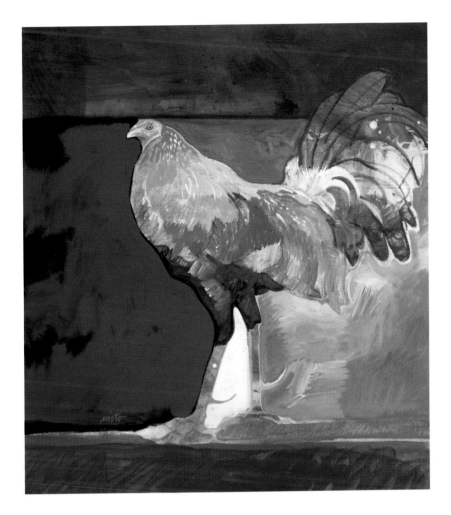

value, but not intensity, throughout this larger negative space, with a lighter blue-purple next to the breast and legs of the bird.

Did you think there would be so many dark-to-light, dull-to-bright, warm-to-cool contrasts in one work?

Let's Think About This Painting . . .

Is there a dominant color?

Is there another color next to its complement?

What would have happened if the white area between the legs, (actually, a high-value blue) were not there?

Why do you think the legs are blue and not some other color?

Let's Think About Color . . .

Do you have chromophobia?

Can you verbally describe the difference between: lilac

purple

lavender

violet

orchid?

Why would you change the intensity of a color?

If you change the value, does the intensity change?

If you change the intensity, does the value change?

Can you describe "pink" by hue, value, and intensity?

Could "pink" have different intensities?

Why would a landscape painter want to know about warm or cool colors?

Why would an interior designer want to know about warm or cool colors?

Can you describe the clothes your colleagues are wearing by hue, value, and intensity? How about temperature?

KEYWORD to remember: COLOR—*relativity; color is an element.*

What Can You Do With Color?

Can color create a focal point? How?

Can color be used as emphasis?

Can color be used to manipulate a viewer's feelings?

Can we divide space?

Can color be a negative space?

Can color be a shape?

Can color be a line?

Can color have texture?

Can color have value?

Can we use color to create balance?

Chapter 9

Use of the Elements

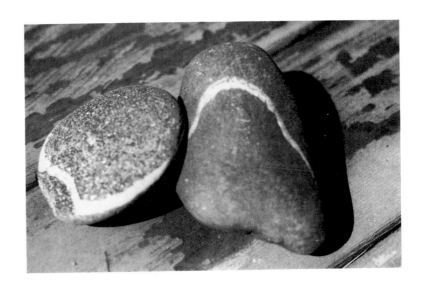

We have now considered all of the design elements. It is as if we were looking at those ingredients for our cake: flour, sugar, butter, eggs, flavoring (chocolate preferred), and so on.

The cake ingredients, like our elements, are not exciting by themselves. They have to be put together and it is HOW they are put together that results in a "WOW" of gratification . . . or . . . an "OHhh . . ." of disappointment.

The *principles* are *how* the elements or components of a design are used or composed. They are considered guidelines only because all these elements can be combined in millions of ways and still be a good design. There is no right or wrong—only designs that work well and those that do not. If the design is successful, all the parts will work together as one total form and will attract and affect the viewer as the designer intended. If it is semisuccessful, the viewer may consider the design momentarily, but not as the designer wished. And if it fails to attract the viewer at all, let alone hold the viewer's attention, it can be considered a failure.

As Edgar Whitney, artist, said, "Every time you make conscious choices in design, you sharpen your taste, and good taste is nothing more than information at work."

We will look at how we can manipulate our elements in our space, considering the following principles of design: space division and balance, unity, and emphasis.

9–1
This placement of two stones is practicing the principles of design with only an aesthetic purpose in mind. "It is salutary that in a world rocked by greed, misunderstanding, and fear, with the imminence of collapse into unbelievable horrors, it is still possible and justifiable to find important the exact placement of two pebbles." *Jim Ede, aesthete and collector.*
S. Brainard, Photo:
TWO STONES

Chapter 10

Space Division and Balance

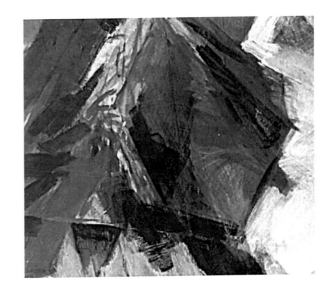

Dividing Space

We are now ready to examine how we can combine the parts to create the total effect we call a design.

First, we choose a space to use for our design. One of the first things we do automatically, without realizing what we are doing, is to divide or break up that space.

SPACE IS BROKEN BY NEGATIVE AND POSITIVE SHAPES

The *instant* we place one shape into a negative space, we have "broken" the emptiness of that space. Think of it in terms of something tangible, like putting one chair into an empty room. This placement immediately creates a charge of energy in the space. It breaks up the space and makes both the space and the shape more interesting.

As we place a *second* shape into our space, we break up the space even more, and we now have to start thinking about the *relationship* of our shapes to *one another,* the relationship of our shapes *to the space,* as well as the *negative shapes* that may be formed in the process. The more shapes or lines (which are also positives) that are added to our space, the more complicated this relationship becomes. It becomes a **complex** design, as opposed to a **simple** design, where only a few shapes or images are used.

10–1
Diagram 1. A shape put into a space breaks up the space. This action energizes the space.

Balance

When we divide or break up our space, we commit a physical act. Think of it as something we actually DO in our space. We make it happen.

We, as humans, tend to see bilaterally—from side to side rather than up to down. In Western culture, we usually look at a two-dimensional space from left to right. If, then, we place something on the left with nothing on the right, we perceive an "implied axis," or "a line that really isn't there," down the center of our space, dividing the space in half; we create a design that forces the viewer to make a *mental* division of the space. We are an orderly people and we want those two halves to balance or we feel uncomfortable with the design.

10–2
Diagram 2.

10–3
Diagram 3.

10–2

10–3

Often viewers don't know WHY they don't "like" a design; they just don't. It doesn't fit their need for harmony and balance even though they may not know it. So balance and space division affect one another.

Let's define BALANCE as positive and negative spaces or shapes distributed in space by apparent VISUAL weight. We can use any or all of our elements to create balance. We may balance a shape with lines, or lines with value, many lines together to balance a color, and obviously shapes to shapes, and the like.

There are known balance systems we can employ—ways to use our elements to achieve a balanced effect.

I think it is important to be aware of several of the most frequently used balance systems and the differences between them.

Kinds of Balance

When we divide our space with that "implied" vertical axis and divide our space equally into halves, the easiest and most common balance system to employ is **symmetrical** or **formal**. *Formal balance has the exact identical weight on both sides of the implied axis.* A very technical definition of this balance system is that not only are both sides identical in weight, but they share *identical imagery in reverse.* This is called "mirror image." Formal balance is instantly understood as it requires little of the viewer. It is exacting, non-casual, and quiet, but can also be boring.

10–4
Diagram depicting two
identical shapes in
mirror-image reverse creates
immediate *formal* balance.

10–5
Both sides of the chest are exactly the same, but in reverse. An example of *formal balance.*
Eighteenth-Century English Mahogany High Chest. Courtesy: Baker Furniture, Grand Rapids.

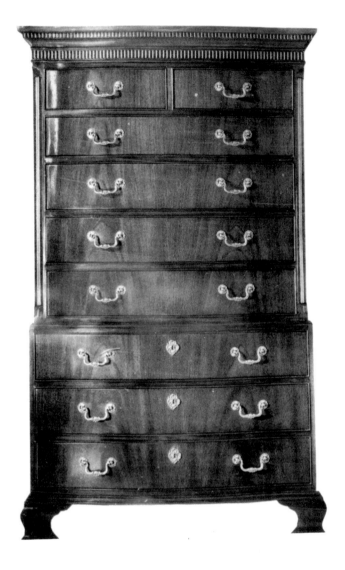

The second most common balance system is **asymmetrical**, or **informal** balance. In this system, the space may be divided in unequal parts and, therefore, the elements must be placed with care to distribute the weight and create the needed balance. The *visual weight* is EQUAL but NOT IDENTICAL. This system is really used more extensively than formal balance or any of the other balance systems. It is more gratifying because it is more casual and more interesting. It is, however, harder for the designer to achieve and also asks more effort from the viewer.

10–6
Diagram depicting *informal balance*. A large shape and several smaller shapes suggest the same *visual weight* distributed equally.

10–7
The elements in this painting have been distributed in order to achieve *informal balance*. *Shirl Brainard, SPIRIT OF THE SIPAPU, Acrylic on masonite, 18″ × 24″, 1989.*

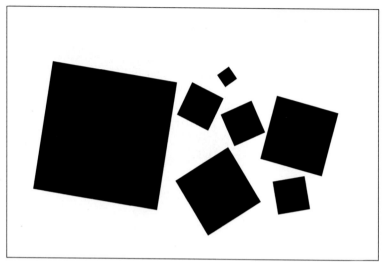

10–6

10–7

10–8
The shapes are the same but mirror-image reversed. Other shapes may be similar to one another, but not the same. At first glance, a viewer may "read" that they are the same. This illustrates *approximate symmetry.*

A third system that is seldom mentioned in design texts but which I feel is important to know about is **approximate symmetry.** This makes the distinct technical differentiation between exact SYMMETRY, or "mirror image," and that which is often *perceived* as formal balance and *is not.* The *visual weight appears identical.* I always feel someone is practicing a little deception—leading me to perceive the design as formal, yet realizing it is a kind of informal balance, or a mixture of the two. This approach can relax a design that calls for being somewhat formal but does not require the exactness or the mirror imagery of a strictly formal system. Often you will notice that this balance system may be called formal or symmetrical in instances where the precise technical difference may not be important. I feel we should be aware of this difference and be able to use the system. A dying design may be saved by resorting to just this type of variance for the maximum visual effect.

10–9
These doors with their very similar, but different, two sides represent *approximate symmetry* balance.
Gary S. Griffin. DOORS. 81" H × 66" W × 2½" D. Hand-wrought steel. Courtesy: Gary S. Griffin.

The last balance system is **radial balance.** This system uses a center or radius. The elements radiate from this center point and the *visual weight* is distributed collectively, creating the feeling of equilibrium.

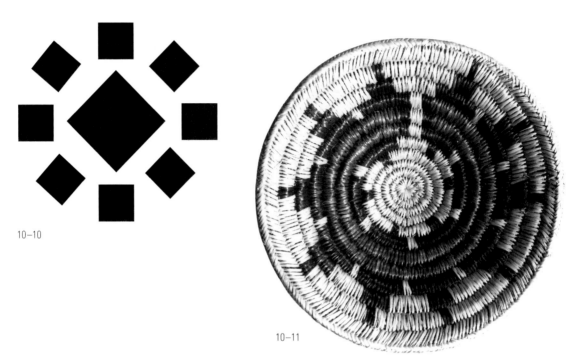

10–10

10–11

10–10
Diagram: *Radial balance.* Shapes arranged around a center, or "radius." The visual weight of the smaller shapes is collective.

10–11
The basket is woven from the center, expressing the concept of *radial balance. S. Brainard, Photo: NAVAJO WEDDING BASKET. Collection of the author.*

10–12
An architectural form based on *radial balance. S. Brainard, Photo. VICTORIAN-STYLE GAZEBO.*

10–12

What happens when we take objects of identical imagery and place one on each side of our space? Or place different images in each "corner" of our space? We may question whether we are using the space to the best advantage, for one thing. Would you put a different chair in each corner of your living room?

10–13
Would you put your living room sofa in the center of a room and a chair or table in each corner?

10–14
Diagram. Grid effect.

10–13

10–14

The visual response, again, is a mental division of the space into halves or quarters. The halves that are the same or appear to be the same (formal or approximate symmetry) can be soothing or boring, depending on the imagery and the function of the design.

The quarters, however, tend to make us see four "squares," or a grid effect. The images lead the eye from one imaginary square to the next. Often this is acceptable and, in fact, is commonly used to unify diverse subjects, as we will examine later. It is an automatic way to unify and balance elements, but its use must be chosen carefully. Simple all-over pattern—using the repetition of a motif—is based on this balance concept. But would you use it in a room arrangement? Would you design a refrigerator with four equal spaces? What would happen if you designed a landscape painting in this way?

Let's Think About Space Division . . .

Why does the division of space affect BALANCE?

Are all designs divided within their space?

Are all the spaces equal?

When might it be possible to have a design divided in equal parts?

Can you see *where* and diagram *how* this design is divided?

10–15
Oneida Silversmiths, Stainless steel tableware, Ridgecrest design. Courtesy: Oneida, Ltd., Oneida, NY.

KEYWORD to remember: SPACE DIVISION—space is divided by POSITIVE and NEGATIVE SHAPES. (Don't forget that lines are positive.)

Let's Think About Balance . . .

To create *balance:* Do shapes have to be the same *kind* of shapes?

Do shapes have to be the same size?

Do shapes have to be the same value?

Do shapes have to have the same texture?

Do shapes have to be the same color?

Do shapes have to have the exact same visual weight?

What kind of balance would require all of the above?

Can lines be used in a design when you are trying to create balance?

Can shapes and other elements be manipulated to appear to have the same visual weight?

Figure 10–16 is a diagram of how to make some geometric shapes. Prepare some so we can do some "visual thinking" while we physically manipulate the shapes in a given space. You should have 3–4 values, from very light gray to black. For your spaces, use white papers: one 8″ × 10″ and one 4″ × 5″.

What Would Happen If . . . ?

You used your largest black square and largest gray square on either side of an equally divided space on your small space?

Which appears heavier?

What happens if we turn the gray square?

What happens if the gray square were larger?

What happens if you turn the black square?

KEYWORD to remember: BALANCE—positive and negative shapes distributed in space by *visual* weight to create harmony.

10–16
Geometric shapes for you to
copy and use.

Ideas to Try Dividing Space

Use the following spaces; try and divide each space into three sections, using line.

10–17
Spaces to work on.

Do you see you have broken up the space?

Think—the parts have become "shapes."

Think—are any of the divisions equal?

Could two parts, or sections, equal one part?

What Would Happen If . . . ?

You add a dark value to one shape?

You add two different values to two sections?

You add many lines to one section?

Is the balance affected?

Ideas to Try for Balance

Using your cutout squares, on the biggest paper, experiment with all four balance systems. First, use your space horizontally, then vertically; you will see that there *is* a difference.

Now try using some varied shapes on your smaller space. At first, try only the black squares. It will be easy to create all of the systems. Now try substituting gray values for your black squares. You have changed the value and therefore the weights, visually. Try other squares of different sizes or textures, or add lines with a pen.

WHAT HAPPENS?

More Ideas to Try for Balance.

Grouping small shapes to counterbalance a large shape.

Grouping small shapes to counterbalance a dark shape.

Trying active textures with darker values, and lightly textured surfaces with lighter values.

Irregular shapes being considered as visually heavier than more easily recognized shapes.

Using a bright color to balance less bright colors that are of a larger mass.

Placing shapes above eye level to add visual weight.

Lines placed closer together will appear darker and can help counterbalance a dark valued solid mass.

10–18
How is the space divided? What element is used the most? What kind of balance system is used?
Artist unknown, perhaps a child's work. MOLA. Courtesy: Gail Johnson.

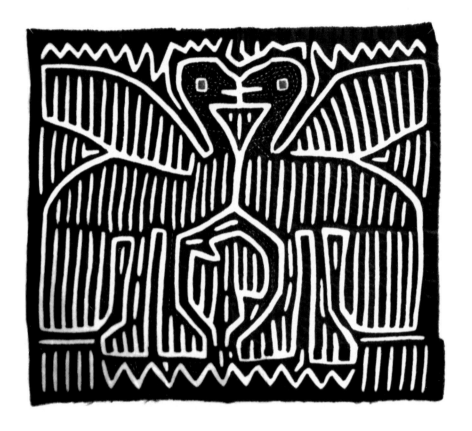

Can You Identify . . . ? (go back to figure 8–29):

How is the space is divided?

Why the tiny blue line, from the foot to the rear right space, is important? What does it do?

What colors help to balance each other?

What values help to balance each other?

What balance system is used?

Review

content	The message created by the artist. May be functional for consumer purposes; iconography.
intent	What the designer or artist intended with the design; may not have content or message.

space division	Space divided by the use of positive and negative shapes.
simple design	Few elements used in the space and in the composition. Not difficult for a viewer to comprehend.
complex design	Complicated as opposed to simple. Many elements used so is harder to design and comprehend.
balance	Positive and negative shapes distributed in space by apparent *visual* weight to create harmony.
formal balance	(SYMMETRICAL BALANCE)—Technically, a mirror image: elements on either side of the implied axis having precisely the same shapes, *but in reverse*—and having the identical same visual weight.
informal balance	(ASYMMETRICAL BALANCE)—A balance system in which the visual weight on both sides of the implied axis of elements is equal. Elements often cross the axis.
approximate symmetry	A balance system in which our first impression is that of symmetry. Weight may be identical but not mirror image.
radial balance	Created by repetitive equilibrium of elements radiating from a center point.
implied axis	A "mental," psychological division of space. Usually centered, or perceived bilaterally.

11–3
Rhythm. More variance and more repetition and a more active way of positioning the shapes makes the whole more lively.

We have added different values and sizes. The smaller squares are placed in such a way that they carry the eye from one shape to another. The up and down position contributes to a "beat" in the composition. We have created the last part of our unity: RHYTHM.

Rhythm

Rhythm means "a recurrence of movement." In music, the repetition and variety of notes create the rhythm that we remember, identify, and perhaps hum or whistle. In a visual work, RHYTHM is also created by repetition and variety. The way these two components are used gives us movement, both emotional and visual. As our eye travels around the design, we may experience an upbeat feeling, or we may be left with a not-so-good sensation. The "visual path" our eye follows can be influenced by the *way* chosen elements are aligned or repeated. Windows repeated in a building may take our eye around

and through the design, the same as the repetition of a color, in a room. The kinds of shapes used and how they are used together will decide the feeling. Some designs are stable, static designs, such as our refrigerator. We don't need an "exciting" refrigerator. What we *do* need in our refrigerator is a combination of well-proportioned geometric shapes, combined in a way that makes us feel we have a clean, dependable article that will keep our food fresh and cold. But what about a sports car? A sports car's sleek, geometric shapes are aligned in long, tension-filled horizontals. It makes us think of sophistication,

11–4

The emotional rhythm or sense of physical action is created by the repetition of the perfume bottle flying through the negative space as well as the exuberance of the figure. *Bijan Designer for Men, Advertisement for Bijan Fragrances. BIJAN IN SWEATSHIRT. Courtesy: Bijan Designer for Men, New York and Beverly Hills.*

11–5
The refrigerator—again!

money!—speed! Other horizontal alignments, such as a landscape, may make us feel restful, peaceful, or even lazy. Landscape shapes will probably not be angular ones, as in the sports car, but soft, curved shapes undulating horizontally with little or no opposition.

Because this concept of mood, or "emotional movement," is often hard to grasp, let's think about one more example. A penal institution should have good exterior and interior design. It needs to function in a specific way. Architecturally, it could look decent, acceptable, BUT should it look welcoming? Should it be designed so that many of us would want to go in? Should the interior be so inviting and comfortable you would never want to leave? Churches, on the other hand, are designed to welcome, to enfold, and, once inside, to inspire exultation. Our homes should reflect our tastes, likes, and dislikes so that we are happy to get home after a long day out in the world.

Colors, textures, animation—many things contribute to our sense of rhythm in our designs. We will learn more about how to use rhythmic "devices" later in the book.

Shapes can also leave the space and return. This is a variation of the position or location of a shape. There can be a danger here, also—that of directing the viewer's eye out of the space and not returning it. An example is this working drawing of Piet Mondrian's early in his artistic career. He has used a natural shape and placed the shape horizontally

11–6
Piet Mondrian.
CHRYSANTHEMUM.
Drawing. 1906.
© Mondrian Estate/
Holtzman Trust

in the space, giving a relaxed feeling to the subject. But it is *so* relaxed that it elicits a ho-hum response from the viewer. In the drawing below, he has placed the flower on the diagonal in the space, bringing more excitement to the composition. It directs the viewer's eye into one corner of the space, with the strong possibility of taking it OUT of the space in the opposite corner. Let's look at this drawing carefully, think about the elements, and see how we can direct the viewer's eye. The flower's head is a round shape. The stem is perceived as a line, dividing the space. Our eye will come in at the corner of the space at the *end* of the stem, follow the line of the stem, go *around* the head, and *could* turn around and go back *out of the space!* Why doesn't the eye do that? Our eye is stopped by the area of a dark *value,* the space division, and another small linear area of value in opposition to the stem line. The careful *placement* of values, shapes, and lines serves to solve the problem and create a rhythmic path that controls the eye and keeps it *within* the space.

11–7
Piet Mondrian. DYING CHRYSANTHEMUM. Charcoal drawing. 1907. 30¹¹⁄₁₆″ × 18⅛″ © Mondrian Estate/ Holtzman Trust

**Little prints.
Warner Wallcoverings**

Available through interior designers and decorating departments.

12–6
The size contrast makes it impossible not to see the product advertised. *Bijan Perfume for Women. Beverly Hills, California. Courtesy Bijan.*

12–7
The contrast of values indicates a focal point or emphasizes what the viewer is meant to see.

12–8
The value contrasts—the shadowed areas against sunlit areas—make one see the carriage and horse.
S. Brainard, Photo. NOT A ONE HORSE TOWN (Chicago).

12–7

12–8

12–9

12–9
An *anomaly* is something "out of place": In this example, the circle is "out of place," so it is readily seen.

12–10
Beautiful geometric gems nestled in a bed of peas are an anomaly.
PEAS AND CARATS, Jewelry by Bijan, Beverly Hills, California. Courtesy: Bijan.

12–10

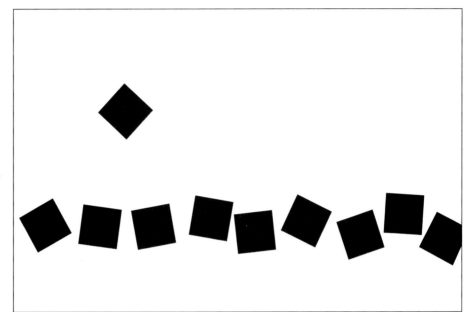

12–11
The contrast of position of one shape to similar others creates emphasis. The eye interrupts its travel to look at that shape.

12–12
Daniel D. Morrison. Photo for Texas Dept. of Agriculture. A SUNFLOWER FIELD. Courtesy: Daniel D. Morrison, Dripping Springs, Texas.

12–11

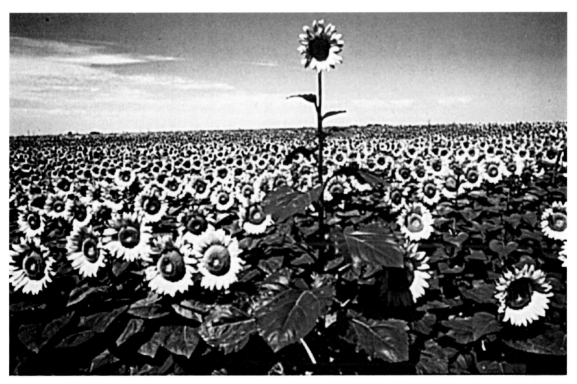

12–12

ANY CONTRAST CAN BE MADE TO WORK!
BY THE WAY . . . WHAT IS AN ANOMALY?

An **anomaly** is a deviation from the normal, or what is considered ordinary. If I go to the beach on a hot day dressed in a muffler, mittens, and winter coat, I am an "anomaly." People would notice me! We all, at one time or another, have felt we were "different" from others in a given circumstance, or didn't "fit" into a situation. At that time, we were "anomalies"—or thought we were.

Anomalies very efficiently create emphasis by directing the eye quickly and surely to the area we want the eye to go.

Obviously, several elements can be combined in our effort to create emphasis: A textured area may have a defined color; a shape that is an anomaly to other shapes may also have a contrast of values; and so on. The ideas one can generate with contrasts are endless.

Selection

Emphasis is often a matter of selection. Students (and professionals) often can't decide what they really want the viewer to see. This is especially true in drawing and painting. In designing, we want to direct the viewer's eye by using rhythm (to get him on the visual path) and emphasis (to make her stop and look). We must also pare down the nonessentials.

Once again using baking as our analogy, let's think about our chocolate cake. We already have a fine recipe for our cake, but then we decide to add some nuts. Good . . . they go well together. And how about a banana? Some raisins? Pineapple?

What is happening? The emphasis is no longer on a CHOCOLATE cake. It has become another kind of cake, and although we may have created an excellent new cake, the chocolate *essence*—or CHOCO-LATE emphasis—has been diminished.

We must economize so as not to use more than what is needed for an excellent design.

Remember: LESS CAN BE MORE.

Let's Think About Emphasis . . .

What might you emphasize when designing or decorating your living room?

What might you emphasize when designing a refrigerator?

What might you emphasize when designing a garden?

What might you emphasize when you are dressing (designing) yourself?

What do you think a chef might try to emphasize?

What do you think a choreographer might emphasize?

What does tying a yellow ribbon on a tree mean?

What are ways in which we might emphasize our house if we are having a party?

HOW MANY OF THE ABOVE ARE FOCAL POINTS?

KEYWORD to remember: EMPHASIS—*contrast*

Ideas to Try for Emphasis or Focal Point

Go back to figure 11–12. WHAT WOULD HAPPEN IF you created a focal point? How could you do this?

Use your cutout, valued geometric shapes, or make more. You might also consider adding line.

CAN YOU MOVE YOUR SHAPES AND LINES AROUND TO CREATE THE CONTRASTS WE TALKED ABOUT?

Did you create an ANOMALY?

Did you tend to use one kind of geometric shape more than any other?

Do you prefer that kind of shape?

Do you know why?

What could this tell you about yourself as a designer?

Can You Identify . . . ?

Which figure in figure 11–13 is the focal point? WHY?

Which CAN in figure 8–27 is the focal point? WHY?

Review

emphasis	The main element or focal point; what the viewer's eye should see first.
anomaly	Something that is noticed because it differs from its environment.

Part

4

APPLICATION OF PRINCIPLES OF DESIGN AND MORE

Chapter
13

Shape Relationships

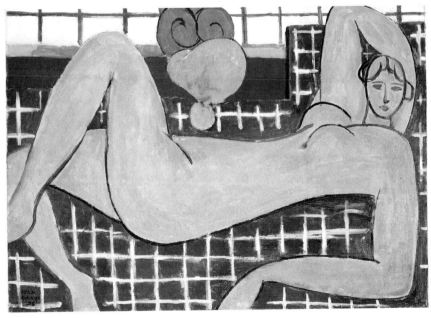

Safety Nets

The information we have just studied is essential to a design. Any effective design must include elements, and these elements must be arranged using these particular principles.

But sometimes that isn't enough. Sometimes we get stuck, or we look at our work and it doesn't seem to work. Sometimes we have a "dry period" and need a new direction. We may need a "safety net" or some "device" to help us out.

A **device** is not a design term. It is a word that means, "a way," a "tool," or, as Random House dictionary cites, "a trick for effecting a purpose." So all these definitions are descriptive of the following information, which I call devices.

Shape Relationships

One thing that happens frequently in uneasy design (a design that starts with good ideas but doesn't feel satisfying) is the way our shapes relate to one another or to their space. The "devices" that can help us the most are: SCALE, PROPORTION, PLACEMENT, and TENSION. We can use these selectively when we need them.

Scale. Scale refers to the *size* of one shape compared to another, or to the space it occupies. Look at the following example. Notice how size affects your reaction to this design.

13–1
Claes Oldenburg and Coosje van Bruggen. SPOONBRIDGE AND CHERRY. Aluminum, stainless steel, paint. 354" × 618" × 162", 1985–88. Collection Walker Art Center, Minneapolis. Gift of Frederich R. Weisman in honor of his parents, William and Mary Weisman, 1988.

Proportion. Proportion is the relative measurement or dimension of parts to the whole. It is common in drawing to use one part = X parts to get good proportional representation. One example of this is the adult figure. We usually use the length of the head as a measurement for the rest of the body: One head length equals eight body parts, or

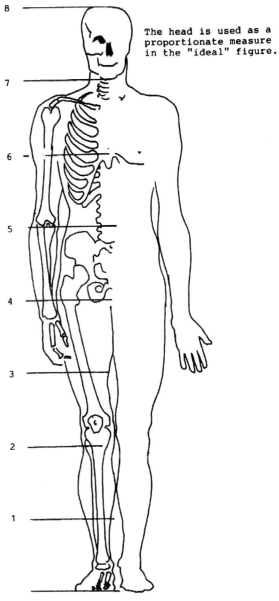

The head is used as a proportionate measure in the "ideal" figure.

13–2
Diagram. Shows how the measurement of the head is used to draw an "ideally" proportioned figure.

"IDEAL" FIGURE PROPORTIONS

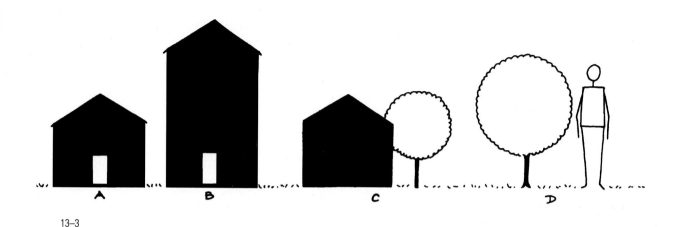

13–3

the whole body. Proportion and scale are often confused and some-times used interchangeably. Let's look at some examples of good proportion and observe how proportioned shapes look with other shapes or spaces. Example A is a well-proportioned house. Example B is not. Why? In example C, the house in the first example is shown with a tree. What is your conclusion? Example D shows the tree with a person. What is your conclusion?

If we change the size of our shapes, we can control the scale and proportion in our design. We can also create more interest because of the variance. This may be one of the first decisions we have to make, as in the case of refrigerator design. We not only need to have inter-esting variations in our size relationships of shapes (which can start with space division), but we must consider the actual inner space usage. A freezer section and the cooling part of a refrigerator are not usually equal. We also have to consider the space into which some of our designs must fit and whether or not they will work in a utilitar-ian, as well as harmonious, way. Another reason for changing shape sizes is that we can control what the viewer sees in a believable way.

So we can say that changing the sizes of shapes can solve several design problems: scale, proportion, interest, space usage (actual or illusionary), or believable content.

13–4
A well-proportioned sofa in a well-proportioned room is still not compatible because of a difference in *scale*. *Advertisement for custom-made sofas. Century Furniture, Hickory, NC.*

Shape Placement. The placement or location of our shapes is important. We have all seen pictorial compositions in which some of the shapes just seem to float, not relating to each other or to the space, and which end up boring the viewer. Let's see what happens when we place our shapes in a more thoughtful way.

In the first example, the person appeared to be the same size as the tree. If we change the shape sizes *and* OVERLAP the shapes, what do we see now? The viewer either thinks the person is in front of the tree, or that the tree is farther behind the person, but that both the person and the tree are of normal size.

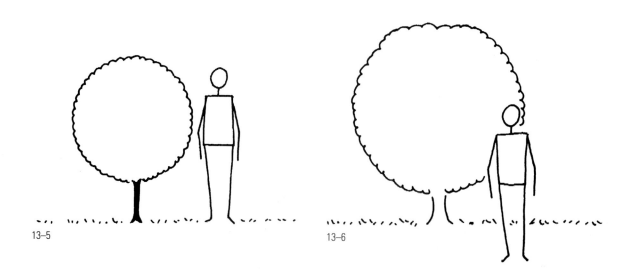

13–5 13–6

In figure 13–7, the circles, we see that several shapes have been changed in size and again overlap some of the other circles. In overlapping, some of the circles appear to be parts of other circles, but they are still seen as circles. Isn't this a more interesting solution than figure 13–8, where the circles just exist in space?

Shapes which do not overlap or come close together are difficult to control. It's as though the space between them becomes boundless and the shapes are forever floating, which is nice if we want the feeling of being airborne. Otherwise, we need to anchor them through their relationships.

We spoke earlier of "visual" space division—when our eye perceives the space in quarters or halves because of the way shapes are placed and balanced. I always use the word "clump" indicating that our eye seems to move awkwardly (or "clump") from one shape to another. I think many students make this mistake because they sense the need for using the space but don't exactly know how. Many times—especially in two-dimensional pictorial designs—students will place their shape of interest in the middle of the space; then, because they instinctively feel a need to do more, they will put other shapes in the "corners." Remember when we talked about this briefly in the chapter about space division and balance? Go back and look at figures 10–13 and 10–14.

We can overlap one or more shapes; we can change the size of the shapes; we can move some closer together or even *almost* touch, or

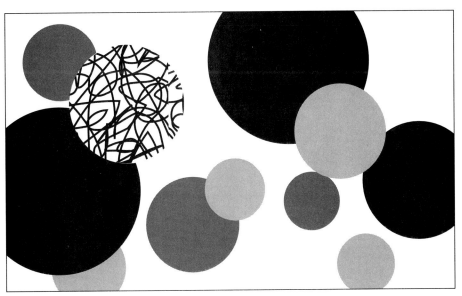

13–7

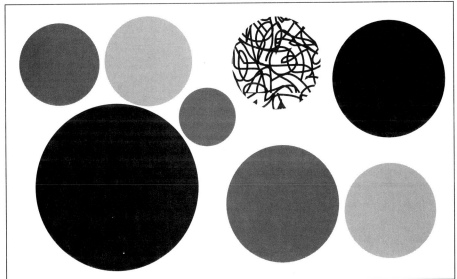

13–8

yes . . . touch. We can cluster or mass many small shapes together. In effect, we "count" them visually and "weightwise" as one shape. This is helpful in the principle of balance.

The way shapes FIT together is also important. Often when students try to vary their shapes, they create too much variety or create

shapes that don't fit together well. If we look at figure 13–9 we see that these four shapes are different. They are variations of geometric shapes. How do we make them work together or FIT together? We use the devices we have been speaking of: overlapping, touching, repositioning. Repositioning simply means playing with the shapes until they all look, feel, and work better together. Try them in different positions: upside down, sideways, half-concealed, cropped, different

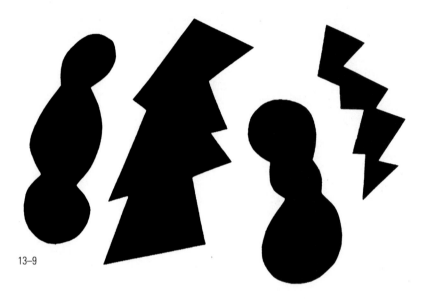

13–9

13–9
What would you do with these shapes?

13–10
Look at how some of the pointed or angular shapes "fit" into the rounded negative spaces; how one shape overlaps another just a bit; the "fifth" shape that emerges between the two positives (a negative shape); all ways that make the shapes relate and work together. *Elizabeth Murray. HEART AND MIND. Oil on canvas 111¾" × 114", Two panels. 1981. The Museum of Contemporary Art, The Barry Lowen Collection, Los Angeles.*

13–10

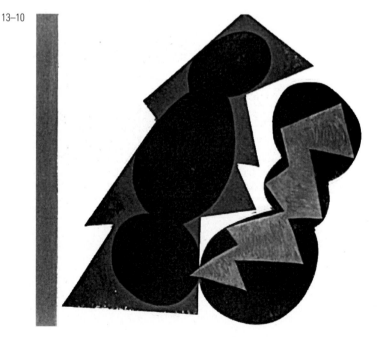

13–23
Henri Matisse (French
1869–1954). LARGE
RECLINING NUDE (formerly
THE PINK NUDE), 1935. Oil
on canvas, 66 × 92.7 cm. The
Cone Collection, formed by
Dr. Claribel Cone and
Miss Etta Cone, Baltimore,
Maryland. Boston Museum
of Art, 1950. #258

13–24
Mark Mehaffey. WHERE THE
HAWK PREYS. Transparent
watercolor 26" × 35", 1985.
Courtesy: Mark Mehaffey,
Williamston.

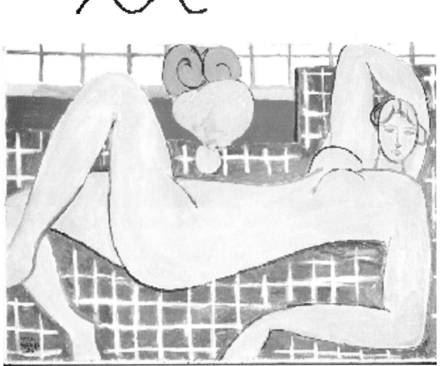

13–23

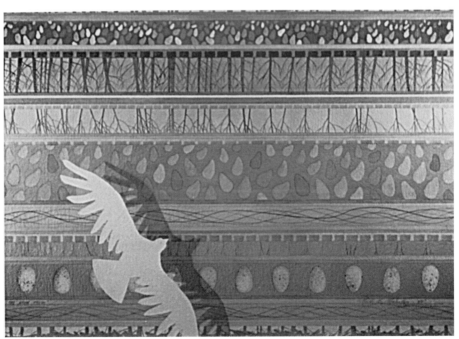

13–24

13–25
Oneida Silversmiths.
Stainless-steel tableware,
Easton design. Courtesy:
Oneida, Ltd., Oneida, NY.

13–26
Winslow Homer,
BLACKBOARD. Gift
(partial and promised) of
JoAnn and Julian Ganz Jr. in
honor of the 50th Anniversary
of the National Gallery of Art,
© 1996 Board of Trustees,
National Gallery of Art,
Washington, D.C. 1877.
Watercolor on wove paper;
laid down (19 ¾" × 12 ¾"),
framed (22 ³⁄₁₆" × 18 ¼").

13–27
Francis Coates Jones,
WOMAN IN WHITE, Pastel on
paper, 14¾" × 17¾", signed
lower left Francis C. Jones.
1857–1932. Courtesy of Hollis
Taggart Galleries, New York.

Use more shapes. TRY: overlapping shapes.
 touching shapes.
 almost touching.
 tension.

DID YOU HAVE A PROBLEM WITH "TENSION?"

DID YOU END UP WITH *ALL* OF YOUR SHAPES DOING ALL OF THESE THINGS AT ONCE? WAS IT TOO MUCH?

Now Try the Following . . .

Move your shapes around and create various "RHYTHMIC PATHS."

Move your shapes around and create an "UPBEAT" mood.

Reassemble and create a quiet, tranquil mood.

Create a "GRID." Can you make a grid with no lines?

Create a "MOTIF." Create a PATTERN with your motif.

Create a pattern with simulated TEXTURE.

Review

device	A tool, trick, or way for effecting a purpose.
scale	The size of one shape or image compared to another or to the space it occupies.
proportion	The relative measurements or dimensions of parts or a portion of the whole.
placement	Location, situation, or juxtaposition of elements.
touch	To contact, adjoin.
crop	To cut off a portion of a shape.
tension	Opposing forces; push-pull, Yin-Yang.
rhythmic devices	Systems of alignments in which to place elements to create a "visual path."
grid	A network of usually straight lines placed at regular intervals.
pattern	Repetition of a motif in either a predictable or random placement.

random pattern A pattern effect because it is a repeated shape or motif, but can be scattered or not controlled as in an all-over pattern. Less formal.

all-over pattern The pattern created when a shape or motif is used in a planned, predictable way.

motif A distinctive, recurring shape (or combination of shapes).

Chapter 14

Analysis of Designs

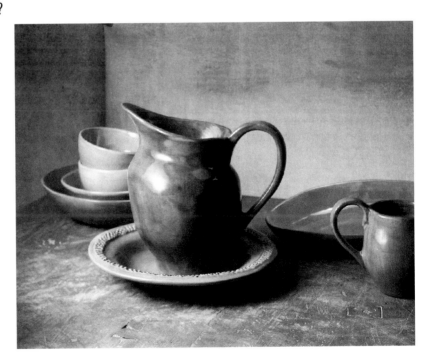

A Design Analysis

We have asked ourselves questions about the elements and then about the principles of design. If we keep thinking about these in order, it enforces the information and helps us to clarify what we take in visually in a systematic way.

IN A GIVEN *SPACE* ARE PLACED *ELEMENTS:* SHAPE
VALUE
LINE
TEXTURE
COLOR

ARRANGED USING THE *PRINCIPLES* OF: SPACE DIVISION
BALANCE
UNIFICATION
EMPHASIS

TO GIVE US A *DESIGN.*

IF WE NEED HELP MAKING OUR PRINCIPLES WORK FOR US, WE HAVE SAFETY NETS OR *DESIGN "DEVICES":* SCALE
PROPORTION
PLACEMENT
CROPPING
TENSION
RHYTHMIC
"DEVICES"
GRIDS
PATTERNS

Let us now look at a famous, representational painting: "PARIS STREET, RAINY DAY" by Gustave Caillebotte, and with our information, we can see how he was thinking as he composed the elements with the principles to create his design.

The FORMAT of the SPACE in "Paris Street, Rainy Day," is HORIZONTAL. *Defining the elements:* The SHAPES are NATURAL (the figures) and GEOMETRIC (the buildings, umbrellas, paving stones, cart and its wheels, and the lamp). The geometric shapes form a background for the natural shapes, being "supportive" shapes and creating contrast to the "people-shapes."

The VALUES in the foreground, closest to us, are dark, especially on the figures. There are mid-values which contribute to the "weather"

Chapter
15

Problem Solving

Problem-Solving Procedure

It has been mentioned that a design is the solution to a problem. So far, we have looked at the elements and principles that are common to all designs. Now it is time to define the problem and the mental process involved in arriving at the solution.

There is a definite procedure to solving a problem, and the time given to each problem will vary from designer to designer. Some designers may work alone while others may have a staff or a "think tank" provided by their company. Whatever the time frame involved, the design will be the result of creative energy directed toward the solution. ". . . There are as many solutions as there are human beings." This was the observation of artist George Tooker.

The following is a general—and widely proved—strategy for finding the best solution to a given problem within the given limitations of that problem.

Defining the Problem. In a recent book, the artist Jennifer Bartlett said, "Give yourself an incredibly restrictive problem you think you can't do anything with. Something that would appall you, like a landscape. Draw an apple. Draw a duck. Draw a turkey." Jennifer Bartlett is a very productive painter and she practices what she preaches. She went to a park and created over 200 interpretations of the same location, using different media with each rendition. She expanded her creativity with each exercise. The point is, of course, that artists *do* give themselves problems to solve.

In other areas of design there may be specific requirements for sizes; for example, cars must be only so wide and so long to fit into existing garages and onto existing highways. Perhaps a requirement will arise because of a societal requirement for an article such as a gold-plated toothbrush. Perhaps only handicapped people will use your product; maybe it is seasonal, or it may be regionally oriented for very specific utilitarian purposes (there are still *real* cowboys who really do wear cowboy boots!). A production cost factor may be a limitation. The list is endless, but so are the *possibilities*.

Possibilities. Any thought that may contribute to the solution of the problem should be jotted down and a sketch made. This is a brainstorming process that puts the initial idea into visual form. One idea may activate another, and the more ideas there are, the better the choices that can be made toward the solution. This may also be a

these trees. Two solutions to this problem may very well be an abstract interpretation, like figure 12–1, or a more representational approach, like figure 8–28. Both artists have solved the problem using their individual interpretation.

Creative license arises from the artist's own viewpoint. It should not mean, in a negative sense, that the artist has *abused* an original idea or a requirement of the problem or ignored the needs of the problem; instead, it indicates that the artist has *interpreted* the solution in a creative way. To gain the desired effect, liberties and deviation from the rule may be implemented. It is the artist's own *expression* of the solution.

15–3
Miss Piggy and Kermit become the incarnation of another famous pair. *Henson Associates, Inc. AMERICAN GOTHIQUE. Kermitage Collection, 1983, New York.*

A famous chef was interviewed about his culinary expertise, and one of his final statements concerned style, which he said, "is like painting or music. You can take the same colors, the same ingredients and interpret them to reflect and express your personality." Humor is often a vehicle used to convey a message, such as cartoons used to make a social or political comment. The humor of the cartoon most often reflects an artist who has a natural bent for being a funny person, in other areas of his or her life, as well as cartooning. That personality can see and present a serious situation in a humorous way, such as the informational cartoon in figure 15–4.

So, you can add chocolate chips to your chocolate cake and that can be YOUR interpretation of CHOCOLATE CAKE!

15–4
Humor used as an implement to get an important message to its viewers. *David Smith, advertisement for investment plans. Courtesy: David Smith and Co. Albuquerque, NM.*

15–5
An example of a photographer being alert to "catch" a visual pun through an accidental happening. Although the photo is blurry, the capture of the *essence of the content* is superb! A record such as this may be used later as reference, possibly as a cartoon. *Richard Larson, Photo. HORSES, VIENNA, 1988. Courtesy: Richard Larson.*

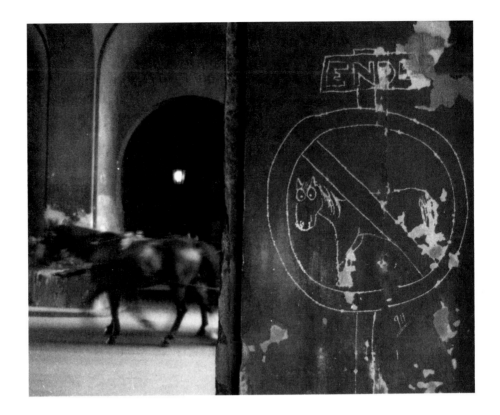

Passion

And last, but maybe the most important of all, is something I mentioned in the Preface. That is your PASSION for your work. Your all-encompassing love for what you do! I will never forget hearing Gerald Brommer say in a workshop, "If you don't love what you're doing, quit bothering the paper!"

Review

problem solving A sequence of strategies for finding a solution to a problem.

creative license Same as "artistic license"; the designer's choices interpret the problem's solution without abusing original requirements.

Chapter 16

Conclusion

A Concluding Thought
A Chocolate Cake Recipe!

A Concluding Thought

We have now concluded our conversational exploration of the fundamental concepts of design. You have gained some helpful ideas to fall back on for extra help; seen a way to use this information in order to analyze a design; and learned how to solve a design problem using a logical procedure. There are more ideas we could talk about, but these are the basics. These are the ones to master in the beginning.

The theory of design is just theory until one starts his or her own exploration and experimentation with his or her own design problems. Experiments are practice, as are class projects, and all are learning experiences. Some will be good, and some will be terrible. NO DESIGNER is successful ALL of the time! And that is what designing is—continual, endless practice. Each new design is a fresh experiment—and each new solution, a revelation. It is exciting that one can use the same elements, the same principles, and even the same problems, yet the end result will always be different, the solutions endless, and the search a forever frustrating, but rewarding experience.

We'll end with one more quote from our friend and teacher Robert Henri: "Keep a bad drawing (design) until by study you have found out why it is bad."

. . . AND THEN MOVE ON . . . !

HAPPY DESIGNING AND CAKE BAKING!

A Chocolate Cake Recipe (using "creative license")

This is a delicious, moist chocolate cake, put together quickly without a single bowl to wash! It is economical, and perfect for today's health conscious world, because it is almost FAT-FREE! And, YES!, you really do need the vinegar . . . it sharpens the flavor.

Preheat oven to 375°.
Space: 9" square baking pan (spray with non-stick cooking spray)
Elements: (ingredients)
 1 cup sugar
 1½ cups flour (over 5,000' add 1½ tablespoons more)
 ⅓ cup cocoa
 1 teaspoon baking soda
 ½ teaspoon salt
 2 teaspoons vanilla
 ½ cup applesauce (the "creative license")

¾ cup cold water
2 tablespoons vinegar

Principles: (Method) Measure all ingredients, except vinegar, directly into cake pan. Mix all thoroughly, then add vinegar and stir quickly to blend. Immediately place in preheated oven. There must be no delay in baking after vinegar is added. Bake 20–25 minutes or until center puffs slightly and sides of cake begin to pull away from pan. Cool. May sprinkle top with powdered sugar.

grid	A network of usually straight lines placed at regular intervals.
hue	A family of color; the pure state of a color.
implied axis	A "mental," psychological division of space. Usually centered, or perceived bilaterally.
implied line	A perceived continuation of images or symbols that imply a line.
informal balance	(Asymmetrical balance)—A balance system in which the visual weight of the elements on both sides of the implied axis is equal. Elements often cross the axis.
intensity	The relative purity of a color; brightness or dullness.
intent	What the designer or artist intended with the design; may not have content or message.
intermediate colors	(Tertiary)—Colors produced by mixing a primary and secondary color.
line	A mark longer than it is wide and seen because it differs in value, color, or texture from its background.
linear shape	An elongated shape that reminds us of a line.
mass	Having volume or depth; takes up three-dimensional space.
medium	The kind of material(s) one is working with, such as pigments, film, fabric, pencil, steel, and the like (plural—media).
motif	A distinctive, recurring shape (or combination of shapes).
natural shape	Shapes found in nature; sometimes called organic.
negative shape	The implied shape produced after two or more positive shapes are placed in a negative (empty) space.
negative space	Completely empty actual or working space.
neutral	The color resulting after two complements have been mixed to the point neither color is evident.
nonfunctional design	Design that is decorative or aesthetic. It is not strictly necessary to our functions as a culture.

nonobjective shape	A shape often made accidentally or invented from another source. There is no recognizable object involved.
original	A primary, inventive form of producing an idea, method, performance, etc.
pattern	The repetition of a motif in either a predictable or random placement.
perception	The individual response to the sensations of stimuli. Often cultural.
placement	Location, situation, or juxtaposition of elements.
positive shape	A shape or line placed in a negative or empty space.
primary colors	Colors that cannot be produced by mixing other colors. Theoretically, all other colors can be produced from the primaries.
principles	Ways the parts or elements are used, arranged, or manipulated to create the composition of the design; how to use the parts.
problem solving	A sequence of strategies for finding a solution to a problem.
product design	The design of necessary, functional items in a society.
proportion	The relative measurements or dimensions of parts or a portion of the whole.
radial balance	Created by repetitive equilibrium of elements radiating from a center point.
random pattern	A pattern effect because it is a repeated shape or motif, but can be scattered or not controlled as in an all-over pattern. Less formal.
relativity	The degree of comparison of one thing to another. How does *a* compare to *b;* then what is the comparison of *a* to *c.*
repetition	The result of repeating or doing the same thing over and over.
rhythm	A recurrence or movement. A "visual path" for the eye to follow; a "visual beat."
rhythmic devices	Systems of alignments in which to place elements to create a "visual path."

scale	The size of one shape or image compared to another or to the space it occupies.
secondary colors	Colors produced by mixing two primaries.
shade	A dark value of a color.
shape	An image in space.
simple design	Few elements used in the space and in the composition. Not difficult for a viewer to comprehend.
simulated texture	The real quality of a tactile surface being copied or imitated.
space	An empty, negative area where our design will fit.
space division	Space divided by the use of positive and negative shapes.
subtractive color mixture	The result of pigments mixed together and exerting their force upon one another.
symbolic line	A line or combination of lines that stands for, or reminds us of, something within our realm of knowledge.
symmetrical balance	(Formal balance)—Technically a mirror image. Elements on either side of the implied axis have precisely the same shape, *but in reverse*—and have the identical same visual weight.
temperate colors	The apparent psychological or emotional state of warmth or coolness of colors.
tension	Opposing forces, push-pull, Yin-Yang.
tertiary colors	(Intermediate colors)—Colors produced by mixing a primary and a secondary color.
texture	The quality of being tactile, or being able to *feel* a rough or smooth type of surface.
theory	The examination of information that often ends in a plausible assumption or conclusion.
tint	A light value of a color.
tones	Neutrals of colors; relative neutral scale.
touch	To contact, adjoin.

unity
: The effect of all the principles being in harmony with one another, creating the feeling of wholeness.

value
: The range of possible lightness or darkness within a given medium.

variety
: The changing of the original character of any element; diversity.

working space
: The space that reflects the actual space. The two *may,* but not always, be the same space. This is the space we use to solve our design problem.

I n d e x

Note: Page numbers with an "f" indicate figures.

NOTES

NOTES

NOTES

NOTES

NOTES

NOTES